THE
Secrets of your
HANDWRITING

THE Secrets of your HANDWRITING

Allan Conway

PORTICO

First published in the United Kingdom in 2015 by
Portico
43 Great Ormond Street
London
WC1N 3HZ

An imprint of Pavilion Books Company Ltd
Copyright © Pavilion Books Company Ltd 2015

ISBN 978-1-91023-236-1

A CIP catalogue record for this book is available from the British Library.

10 9 8 7 6 5 4 3 2

Reproduction by Mission Productions Ltd, Hong Kong
Printed and bound by 1010 Printing International Ltd, China

This book can be ordered direct from the publisher at
www.pavilionbooks.com

Contents

Introduction

Both a science and an art, graphology is the study
of our personality through handwriting. It is not
to be confused with calligraphy, which is the art of
beautiful handwriting.

What is graphology?

Research shows that our handwriting originates not from the hand, as we might expect, but from the brain. Stimulated by brain impulses, two muscle groups work to perform the act of writing. Extensor muscles extend the fingers and flexor muscles draw the fingers in – while brain impulses are translated directly onto the page. So the state of the brain at the time of writing has a direct influence on what appears on the page.

In the 19th and early 20th century, psychologists such as Carl Jung and Max Pulver added a new dimension to graphology by seeing symbols in writings, which could reveal the subconscious drives of the writer. It is now accepted that writing analysis can often get nearer the truth about an individual than shrewd, sympathetic questioning.

Precise in its interpretation, this discipline can assess character through handwriting. Graphology is also unobtrusive and non-invasive, especially when compared with other evaluation techniques, particularly in the area of recruitment.

Medical cases have shown that where people have lost a hand or an arm, and have had to learn to write with their other hand, their writing develops the same characteristics as before. Where patients have lost both arms, then mouth or foot writing also develops with the same characteristics. However, when people become ill, stressed, very tired or greatly troubled, their handwriting changes. There are remarkable similarities that show up in the writing of different people with similar medical or mental conditions, but – as far as we know – no two people have exactly the same handwriting.

How is it done?

Graphologists interpret the strokes, pressures and loops of a person's handwriting, which reveal their strengths, weaknesses and hidden motivations. Every aspect of the way words are formed and set out on the page yields clues. People often think, 'I'll deceive them, I'll alter my usual style.' But by the third line, they have subconsciously reverted to at least certain aspects of their normal script.

There's nothing magical or mystical about graphology – it's simply a precise and detailed process of analysis. As this book will illustrate, it takes into account every feature of handwriting, including the colour of ink chosen, the pressure used, the flow, the slant, the baseline, the zones, the spacing on the page and the gaps between the words. For instance, large first letters indicate a desire to be noticed, comparative distance between words is a measure of individuality, while small and compact writing may indicate intelligence, discipline, thoroughness and precision. So those who think they can hide their personality by changing the shape of their letters can't get away with it that easily. In fact, simply watching someone write can reveal hidden secrets. Individuals often initially disagree with the findings of an analysis, but when they discuss it with those who know them well, the majority find that it is more accurate than they had at first thought.

This is particularly the case when an analysis reveals someone's weaknesses, which they might not have previously admitted or recognised. For instance, the term 'thrifty', which can also be taken to mean 'mean', could be the cause of objection. A man who can afford to give a £10 donation but gives £1 may be seen as thrifty by onlookers; however, he may consider himself generous, purely because he made a donation.

What are its uses?

Graphologists are increasingly being called upon as expert witnesses in court cases, and handwriting analysis, as a form of identification or elimination, is often used in the following areas:

At home
Love and marriage To examine compatibility, sexual orientation, loyalty and faithfulness.
Children To identify gifted children, children with problems, abused children (physically or emotionally); to decide on an educational path; to help employ nannies or domestic staff.
Health To identify potential physical and mental health problems, and assist psychologists and psychiatrists with their diagnoses.

At work

Business In the areas of staff recruitment, team building, partnerships, appointing the right person for the right job, and finding the right job for the right person.

Careers For choosing the right career path or finding a suitable change of direction.

Dishonesty For revealing fraud, forgery of wills, forms and cheques; general dishonesty; poison-pen letters; wrongful accusations; and authentication of signatures and manuscripts.

One of the main uses for graphology is in the selection of employees. How accurate and meaningful are CVs and references? Is the previous employer delighted to get rid of someone? A clever interviewee can fool an employer just as poor or nervous interviewees can underestimate and undersell themselves, which means that employers miss out on capable and suitable staff. But whereas the interview situation is often artificial, the handwriting of a potential new staff member will never hide the truth. For instance, it can reveal:

- **Physical and material drives** An individual's energy and vitality.
- **Emotional characteristics** Feelings, moodiness, and whether emotions trigger dangerous reactions.
- **Intellectual style** Methods employed in problem-solving and attention to detail.
- **Personality traits** Confidence or lack of it, self-esteem or adaptability.
- **Social behaviour** Assessing someone's ability to handle colleagues and clients, and revealing their use of discretion.
- **Vocational implications** Revealing whether or not an applicant has the ability to tackle projects, perform well and be organised.

The first part of this book attempts to set out and illustrate some of the more common and easily recognised aspects of handwriting and what they signify. The second part explains in more detail the uses to which graphology can be put. There is also a section featuring the handwriting and signatures of some of history's most famous figures, showing what their handwriting reveals about them.

First Impressions

As subsequent chapters will demonstrate, every aspect of an individual's handwriting – from the speed and flow, the formation of individual letters, the way letters are or are not connected, to the spacing and margins, baselines, zones, pressure, size, slant, speed, even the colour of ink – is relevant to the graphologist. However, the first or overall impression can be most revealing.

Layout

When viewed on the page, handwriting emerges from the space and also creates a space around itself. It is important to establish the relation between the text and the page on which it sits.

In each individual's life there is an order imposed by social norms and that is the external order that sets the margins of a script. The overall layout expresses how the writer orders or lays out the space in their life and indicates how they structure themselves in relation to the external world. The internal layout gives an image of how the writer feels within that space. The layout also shows how the writer organises their time.

Order

The appearance of handwriting on the page represents an important starting point for the graphologist.

Clear
Clear and legible writing, with good distinction between the words and lines, is generally a positive indication. It shows a clear and logical mind. Firm and confident writing reinforces this. However, writing that is slow and monotonous indicates learned habits and a disciplined and conventional personality.

Confused
Where the distribution of space obscures legibility, the writer is imprecise and disorderly. This can indicate how the writer feels about their own identity and the clarity of their mind.

Orderly

Writing that is clear, proportionate and with precise margins requires further examination to establish whether it is a controlled, stiff, rigid hand or a natural flow. It could show a strong sense of organisation, or an imposed sense of discipline.

Exotic, mysterious, elusive, Japan's geisha have always fascinated and allured westerners from Puccini to Madonna, from Picasso to Arthur Golden. But just who are the geisha?

Disorderly

Disorderly writing can be a result of a positive, active animation, or passive negligence. The writing may appear confused, complex and exaggerated, and for this reason several samples from the same individual would be required to make an accurate assessment. This would help to ascertain whether the samples demonstrate a permanent disorder in the writer's mind and script (indicating laziness and a general lack of adaptability) or whether it is a temporary aberration.

Neat

Orderly writing showing deliberately beautiful presentation is indicative of an aesthetic inclination which, when taken to the extreme, can indicate affectation.

Messy

Messy writing is not uncommon in children, but in an adult can be challenging. Again, several samples from the same individual would be required to reach an accurate assessment.

Aeration

The arrangement of space between words and lines is
also significant.

Aerated

Writing with a harmonious affiliation between the black and
white (of the text and the page), with proportioned space and
circulation between letters, words and lines, is termed 'aerated'.
It indicates a clear, objective, open and independent mind.

Spaced out

Excessive aeration, where the spaces between words are more
than the width of two letters, indicates openness, particularly
when combined with receptive and supple writing. The writer
is likely to be imaginative, inventive and open to ideas, although
excessive spacing is a sign of inhibition and isolation.

The new creatives portray fun lifestyle
moments, representing the uplifting,
feelgood values of Heart 106.2. music
selected for the ads also demonstrates
that Heart's music has moved on to
more contemporary trends, including

Compact

Dense text, where the space on the page is filled, shows that the writer is realistic, but unable to accept the unfamiliar. Compact text encircled by white space indicates introversion.

Tangled lines

Where the upper extensions of one line mingle with the lower extensions of the next line, there is a general lack of clarity. The writer is likely to become deeply involved in what they are doing and is unable to take a distant or objective view.

Invasive

If the whole of the page is covered in writing, with no margins and using large and generous movements, the writer has a large personality that needs to fill all the space and be the centre of attention. However, where the page is filled with small, meticulous writing, the individual is both fearful of solitude and fearful of others.

Irregular

Irregular aeration may be caused by lack of discipline, lack of concentration, instability or general negligence. The writer is easily influenced by those around them.

Chimneys

There is a specific irregularity in aeration which forms a gap travelling from the top to bottom of the page. It is an unconscious phenomenon akin to an eruption of an uncontrolled force which, in extreme cases, can be paralysing.

Where the writing does not fit into any of these categories, the specific aeration between letters, words, and lines has a greater impact on the analysis.

Unnecessary dots

Some writers place dots in spaces and places where they do not really belong: at the beginning of a word they usually indicate hesitation; in the middle, they signal a pause in continuity; and at the end of a word they are an unnecessary complication. Depending on the context, they are usually an unconscious show of anxiety.

Underlined

There are several options available to writers to emphasise a word. It could be underlined, enlarged, written in capitals, or surrounded by inverted commas. However, depending on the context, repetition of this device displays a need for precision and clarity, or a desire for excitement.

The Left-handed Writer

From persecution through the ages, to challenges faced using equipment biased towards people who are right-handed, life for those who are left-handed is not easy. The disadvantage is perhaps felt most keenly when learning to write. However, left-handed people should always remember that they also possess higher levels of skill in other areas compared to their right-handed contemporaries.

Sinister or dexter?

Something that a graphologist needs to know in advance of an analysis is whether the subject is left- or right-handed. (They also need to know the age and sex of the writer.)

Even today, in some cultures, those who are left-handed are shunned or forcibly retrained. There is a lingering superstition that left-handedness is somehow connected with the darker side of the human personality. Prejudice against left-handers is reflected in the numerous associations enshrined in everyday language – right equals good ('dexterous' derives from the Latin for right, *dexter*), left is bad (*sinister* is Latin for left).

There is no extensive agreement on the question of the causes of right- or left-handedness in children. However, it does seem clear that left-handed parents more frequently have left-handed offspring than do right-handed parents. The consistency with which children use one hand in preference to the other varies with age, at least through the pre-school years and sometimes beyond. Although the incidence of left-handedness seems to vary with the way it is measured and with the population studied, it is probably not too far off the mark to say that in the USA roughly one in 20 children are left-handed, while in the UK the figure is more likely to be one in 15.

Advantages and disadvantages

Left-handed children can struggle, unaided, with poor handwriting skills and equipment designed for right-handed use. They are put at a disadvantage from the start of their education, because few schools teach them how to write effectively. Bad habits and awkwardness can sometimes follow, having a direct impact on their future prospects and choice of careers.

In research studies, left-handed boys showed more educational difficulties than their female counterparts. Left-handers were observed by their teachers to have lower reading ability and poorer hand/eye coordination.

Many individuals find it hard to produce clear and legible handwriting and this is a problem not only confined to left-handers. However, on average, right-handers have formed their writing habits by the age of eleven, whereas left-handers generally have not. Nevertheless, in some sports, such as tennis, to be left-handed can be an advantage. Left-handers tend to have better developed right-brain hemispheres, which gives them an advantage in judging the speed and trajectory of moving objects. To support this theory, D.W. Holtzen of Harvard Medical School found that the percentages of left-handed tennis players ranked among the top ten players in the world over a 30-year period were up to five times higher than right-handed players.

Dreams have proved a source of wonderment throughout the centuries. Mankind has long sought to understand and interpret the messages sent from this mysterious realm of our imagination, where waking consciousness may but dimly penetrate. Sleep occupies approximately a third of our life, and the average person will experience a staggering 180,000 dreams during the course of their lifetime. These will range from mundane dreams of everyday occurrences, to one bizarre and surreal to one sensual and

Writing style

The central factor pertaining to left-handedness, from a graphologist's point of view, is the slant of the letters. Certain tendencies we expect from a left-handed person will mirror certain negative features in the writing of a right-handed person.

Many people may be surprised by the assertion that a rightward slant is linked with right-handedness and a leftward slant with left-handedness. The fact becomes apparent when a right-hander is deprived of the use of the right hand and has to learn to write with the left hand. They may acquire sufficient skill to produce a script quite similar to their former writing, but the slant will now be leftward. This can be demonstrated by comparing samples of the handwriting of Lord Nelson produced before and after he lost his right arm at Santa Cruz in 1797.

An extreme leftward slant in a right-hander points to a criminal personality, the sources of whose sociopathic tendencies lie in early life experiences. It is the mark of an individual who builds up defences in the form of negative behaviour and opposition to authority, regardless of the circumstances.

The eminent psychologist Mendel made a study of right-handed handwriting with a leftward slant by investigating the early writings of George Bernard Shaw, William Makepeace Thackeray, Maxim Gorky and Henrik Ibsen. He found that each of them had an unhappy childhood, disturbed by an imbalance in the relationship between their parents.

myself is where the hell can one find stimulating company without parting with too much time or money.

You'll have spoken with Dida since I expect, but the dear young lady & myself want to visit Pete & Henri for a weekend in February

The tendency towards a leftward slant for left-handers is the product of the awkward reality of writing from left to right using the left hand, combined with an element of intrinsic frustration at the disadvantage, and associated stigma, of being left-handed in a world designed for right-handers. Interestingly, this sense of being slightly out of kilter with the mainstream is also the basis of the antisocial tendencies indicated in a marked leftward slant in the script of a right-hander.

But in no way should this slant factor be seen as any reflection on the integrity and worth of a person who happens to have been born with a left-sided dominance.

It is apparent that what graphology can reveal about the deeper nature of an individual must always be qualified by a knowledge of the given circumstances. Deductions and conclusions cannot therefore be based on slant alone, and knowledge of whether the writer is right or left-handed is imperative to the graphologist.

The Zones

Handwriting itself is divided into three distinct zones, which separate and illustrate the mental, social, and physical aspects of personality. In most cases these three zones are of equal size. The structure of the personality lies in the balance of these three zones and they should be taken into consideration when assessing where the strengths and weaknesses of the writer lie. Both writing and the human body can be divided in the same way.

Handwriting zones

The three zones of a script are known as upper, middle, and lower.

(1) **Upper zone** This corresponds to the head, the intellectual region of the body. Script extending above the line into the upper zone indicates the writer's intellectual ability, interest in expanding their mind, and in self-education.

(2) **Middle zone** Movement between the two lines on the page in the middle zone corresponds to the area of the body involved with social interaction, emotions, and how the writer copes with the world in which they live.

(3) **Lower zone** What appears beneath the line in the lower zone relates to biological drives and the need for material and sexual gratification.

Where the upper and lower zone extensions are of similar dimension, the facts relevant to that zone are kept within controlled limits. However, where there is a disproportion between any of the three zones, the larger or dominant zone will point to the writer's overenthusiastic response to that area. For example, a small middle zone between a larger upper and lower zone indicates a gulf between a person's ideals and their ability, which suggests a low achievement level due to reaching beyond their capability. A very short upper loop will indicate a poor response to intellectual interests and little ambition in that area. It could also show a lack of spiritual values and awareness.

Upper zone

The upper extensions or loops are written in varying degrees of size, the normal height being 3mm. Those with higher upper zones will have positive attributes of imagination, intelligence, idealism and ambition, while negatively they may be extravagant or pretentious, or display a lack of objectivity. Those with a low upper zone (less than 3mm) will positively display self-reliance, realistic concepts and modesty. Negatively, they may demonstrate a lack of intellectual ideas and a lack of ambition.

Letters that extend into the upper zone include **b**, **d**, **f**, **h**, **i**, **k**, **l** and **t**.

Middle zone

In this zone exists all the small letters without upper or lower loops. In script these include **a**, **c**, **e**, **m**, **n**, **o**, **r**, **s**, **u**, **v**, **w** and **x**. In capital letters some of these may extend into two or even three zones. These middle zone letters constitute a balance between upper and lower zones. They relate to everyday experiences, emotions and social life.

A very large middle zone relates to writers with overinflated egos. These individuals consider themselves very important and will try to demand attention and expect others to adapt to their ways. They will be unable to hold a balanced view of reality, taking an extremely subjective attitude to personal matters, which to them are always the priority in their everyday functioning. Because their understanding of reality is not usually fully developed, children often produce a large middle zone.

A reduced middle zone usually indicates a personality strain in the everyday social and emotional sphere of the writer. This individual would allow their personal life a very small range, and they may not be confident about expressing themselves emotionally.

Such is the seriousness of the leaks, that I have had to cancel all planned trips away. I cannot now leave the property overnight for fear of rain. I suggest the sooner a serious solution is implemented, the less costly

Lower zone

This is the area of instinctive sexual drive and materialistic concern. This zone comprises the lower loops of the letters **g**, **j**, **p**, **q**, **y** and **z**. Analysis of this zone depends on the length and width of the loop and the pressure with which the stroke is achieved. The length of the loop indicates the length to which the person will go to achieve what they need. The further the individual stretches downward, the further they are willing to reach, expand and grow in this area.

Positive traits of long lower loop writers, with pressure on the loop, show that they are physically active and that they have the ability to persevere in difficult circumstances. This style of writing also indicates strong needs for material and sexual gratification. Negative features of this type of writer include clumsiness, domination and materialism. In contrast, a long lower loop with light pressure displays a businesslike individual with a tendency to be petty-minded and sensually indifferent.

If the lower loop remains unfinished, the writer has failed to integrate past learning experiences into present-day reality; they have probably failed to learn from mistakes and are likely to repeat them.

How nice to hear from you.
Thanks for getting in touch.
I've just got back from a
break in Gambia but I'll
give you a call when I've
sorted things out a bit and
we'll arrange a meeting in
London.

Margins and Spacing

Where a writer places their script relative to the margins of a page – top, bottom, left and right – can be very revealing. Likewise, the spacing between and above and below words can tell the graphologist about other traits, such as organisational ability and emotional stability.

Margins

Have you ever noticed the differences in the margins you leave on the paper?

- How near the top do you start?
- How near the bottom do you finish?
- How far from the left do you begin?
- How far from the right do you end?

The position of the margin is more important than you think. It indicates the writer's attitude to society and is usually formed subconsciously. It may also indicate the extent to which the writer is held back in life by past experiences. Here are the most common examples:

Typographical (centred and justified) layouts

These show a need for privacy. This often indicates a person who needs to be clearly understood, especially verbally. There is reserve, pride and a consistency of purpose.

> In the time of swords and periwigs and
> full-skirted coats with flowered lappets – when
> gentlemen wore ruffles, and gold-laced
> waistcoats of paduasoy and taffeta – there
> lived a tailor in Gloucester.
> He sat in the window of a little shop in
> Westgate Street, cross-legged on a table, from
> morning till dark.

Narrow left margins

These indicate a writer who tends not to seek personal social contact. There is a fear of the past and possible thriftiness, as well as practicality.

It was a dark and stormy night
And the nanny goat was blind
She backed into a barbed wire fence
And hurt her never-you-mind.

Narrow right margins

These show the writer wishes to communicate and relate to others. Often garrulous, determined to move forward, this person likes to be individual in everything.

I like travelling, and now that my children are grown up I would like to visit interesting places and meet people from different cultures I enjoy trying different foods and observing people who have a different lifestyle. I would enjoy going to Israel

Absence of margins

This indicates a writer who needs to communicate. They feel they have a lot to say and never quite enough time or space to do so. There is a tendency to miserliness. However, the age of the writer must be taken into consideration. Had they been at school during wartime, for instance, then the shortage of paper would have been emphasised frequently.

we'd like as many people as possible to submit handwriting to give the graphologist, Allan Conway, as big a range as possible to choose from. All analysis in textbook section of the work will be done anonymously and

Wide left margins

Often the result of fast writing, this is usually a sign of intelligence and independence as well as an impulsive urge to save time. Such people tend to lose control and splash themselves over the paper.

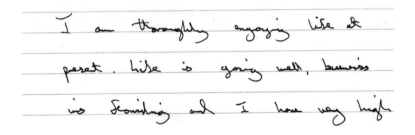

I am thoroughly enjoying life at present. Life is going well, business is flourishing and I have very high

Wide right margins

These show that the writer avoids becoming personally involved in anything progressive and is wary of contact with others. They have a fear of change.

Help children take their first steps towards numeracy
as they have fun with the aliens and astronauts on
Shape World. Learn about flat shapes as the astronauts
follow mysterious footprints. Then discover aliens made
of spheres, pyramids, cuboids and cubes!

Very wide margins

These indicate someone strongly influenced by the past.

Irregular margins

These show a helpful individual, who is sensitive to other people's feelings, but could lack a sense of order.

We concluded that the proposed merger
would have an adverse effect on future
competition for the sale of advertising airtime.
As a consequence, it might be expected to
operate against the public interest. We
considered that London was the primary focus
of competition within ITV, but believed that
there was some competition between ITV regions
outside London.

Large top margins

These show respect for the reader, and are usually a sign of good education and an appreciation of art and culture.

Style and design are always at the top of the list when it comes to creating a new car concept, and the best examples of this can be seen in great-design Icons such as the Ford Mustang, Chevrolet's Corvette, and GM's Cadillac which all had, and still have today, that x-factor that we crave.

Large lower margins

If the text is well balanced, top and bottom, this shows a lack of worry. If the text is concentrated in the top area of the page, there is a lack of organisation and foresight.

The silver swan flew alongside the bed, her great wings thrumming in the air. Soon the bed began to fly lower and dropped gently into the marketplace by the castle. Great was the rejoicing when the people saw Prince Loctat and Lynnet both safely returned.

Convex margins

These mean that the writer makes a strenuous effort for self-control, with little success. Resolutions and decisions only last for a short time.

> The Beatles were truly unique.
>
> In these dark days, there is still a nostalgic thrill in seeing a rare photo of the last time Paul, Ringo and George played together.
> In John Lennon's words we can only imagine what more great music might have resulted if fate had not robbed us of the Fab Four.

Concave margins

These show a relaxed attitude. The writer seems, on the surface, to be controlled by a sense of economy when, in fact, they may have liberal spending habits.

> The most spine-tingling moment of television this week came during Mandela, the Living Legend (BBC 1) when the great man was recognised in a hotel lobby by one of the staff.
> "Mar-deba!" she shouted, transported into some sort of trance.
> "A colossal man who has earned enemies! Who was victory! Oh Mandela! I have waited for this month."

Spacing

As well as the margin or space which a writer leaves around
their text, the space between words and lines is an extremely
useful gauge for determining the writer's organisational abilities.

Even spacing

Evenly distributed writing, with the writer dominating the area
without getting lost in it or taking up the whole of the page,
indicates an individual with clarity of thought, good judgment,
emotional stability and the ability to overcome problems.

> the volcanic activity. Also it would be interesting
> to witness Björk in her native land, singing
> her songs. And all the snow would put me in
> a festive mood for the Christmas holidays!

Compact/cramped spacing

Writing where letters, words and lines appear close together
reflects a spontaneous and impulsive individual. Minor details
tend to hold the attention of the writer, who is usually talkative
and may, at times, unwisely divulge information.

> Through torrid afternoons, entire populations will present
> themselves before you, their hands raised in applause, their
> eyes wide open to catch a lasting memory of the battle. In

Wide spacing

Wide spacing is often an indication of extravagance, self-confidence and sociability. The writer tends more and more to lose contact with life. However, impatience at the time of writing could also be a factor.

 The spacing which a writer leaves between words is symbolic of the distance they wish to keep between himself and society.

Please find enclosed my handwriting sample – I give permission to use the sample.

Very narrow spaces between words

The writer craves companionship and fears loneliness. In extreme cases, this can also indicate a selfish need to be centre of attention. It is a characteristic frequently seen in the writings of media personalities.

Very wide spaces between words

This displays a desire for isolation and an inability or unwillingness to communicate with others.

Extremely variable spacing between words

This shows a high level of insecurity. The writer craves company, yet does not really rely on or trust companionship. This could be caused by immaturity or anxiety.

Rigidly regular spacing between lines

This indicates immense control and fear of relaxation, which the writer equates with loss of self-control or loss of control over external circumstances.

Wide spacing between lines

The writer withdraws from close contact with all but a few people, and is likely to have an inflated view of their own importance. This spacing is often found in the writings of media celebrities and extremely wealthy individuals.

Narrow spaces between lines

The writer has usually written at speed and is full of nervous energy, with thoughts and ideas tumbling out one on top of the other, resulting in a jumbled look. The more entangled the letters and words are on different lines, the more the writer's thoughts are 'tangled'. Feelings are being poured out, rather than being expressed in a way that can be easily understood.

Variable spaces between lines

This can indicate sudden changes from friendliness to apparent hostility as well as a changeable attitude to the accepted boundaries of socialising. The writer is likely to be subjective, confused and even self-centred.

Baseline

The baseline helps determine a writer's emotional state of mind. Writing may slant upward or downward on the paper, or proceed straight across the page. It is one of the few changeable aspects of a person's handwriting and can often vary, depending on how emotional the individual is.

Types of baseline

Identifying the baseline allows an insight into an individual's state of mind at the time of writing.

The direction of the baseline itself indicates whether someone is motivated from within or allows themselves to be swayed by external circumstances.

Those who traverse the page in a straight line with determination and conviction are self-motivated. The writer who has straight baselines has the ability to plan ahead and has a clear sense of direction. They can be a reliable and productive worker, well able to keep things in perspective and under control. However, they may also be competitive and aim to win for the sake of obtaining a goal.

The writer with a wavering baseline is more responsive to their environment. People and situations can motivate or excite them. It may be difficult for them to make long-term plans as they prefer to see what tomorrow will bring. They may be capable of many things, but will not necessarily excel in a particular field.

Straight baseline

A straight baseline is a sign of emotional stability – someone less susceptible to mood changes, with a good sense of balance, self-discipline, and organisation.

According to Keith Middlemas, 'The extreme shortage of labour and the limitless demand for supplies of munitions gave the shop stewards considerable power. The stewards nevertheless failed to turn their power to advantage

Rigid baseline

However, writing which displays rigid regularity indicates that
the writer's disciplined sense of duty and obligation dominates
their feelings, usually resulting in a dull personality.

For the record, I don't normally write
on alternate lines - so don't interpret
it. as some strange deviancy in my
personality!

Upward baseline

An upward baseline shows that the writer is creative, eager and
outgoing, with a healthy outlook on life, displaying ambition and
vivacity.

Rock star Sting wanted to tell his German audience
he was not on stage. "Ich bin warm," he told them, which
unfortunately translated as. "I am gay". Foolish Words - a book
that could easily be retitled I Wish I Hadn't Said That.

Slightly downward baseline

A slightly downward baseline reveals dissatisfaction or inner unhappiness. The writer regards the future with uncertainty. However, it may sometimes simply be caused by fatigue and must be assessed within context.

Sharp downward baseline

A sharp downward baseline usually indicates serious problems or illness, probably of an emotional nature. Other characteristics may include listlessness and a pessimistic outlook on life.

Nous devons partir un peu
plus tôt que prévu et c'est
demain .10 h que nous partons
non par le Train, mais par
route. Il m'est donc impossible
de me rendre à votre aimable
invitation et je le regrette. Après
les examens du 28 et 29 Janvier,
peut être houverons nous un ...

Irregular baseline

Writers with irregular baselines are usually adaptable, but
have poor self-discipline and do not have the same degree of
control over their emotions as the regular writer. They tend
to be excitable and are easily thrown off balance by awkward
situations. Not being easily contented, they will become moody
and restless when restricted in any way and will often show an
intolerance of routine.

Movement

Movement is the basic element of handwriting which creates the forms. It is a subconscious component, closely related to motor behaviour and corresponds to the unconscious motivating forces of the personality. Eminent graphologists such as J. Crepieux-Jamin, H. de Gobineau and S. Bresand identified various types of movement, indicating achievement, potential and dynamism.

General movement

Different types of movement offer the graphologist an
immediate impression of the writer.

Static or immobile movement

Static writing is script that progresses steadily and regularly; it
naturally appears uniform and monotonous.

This type of writer dislikes change. They are scrupulous in their
work. They are good at executing jobs where regularity and
pattern are important. They would be happy working all day in
front of a computer with pre-set guidelines. However, if they
were working in a sales department, where customers are likely
to dither and frequently change their minds, it could well have a
devastating effect on the business.

Fluctuating movement

The writing is irregular and uncertain in its progression.
It lacks solid stance on the line. It looks as if it moves in place.
The pressure is light, the writing is not firm, and the structure
is almost insufficient.

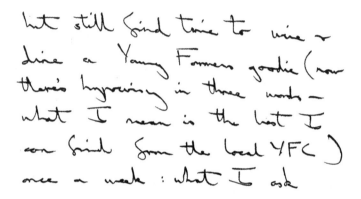

This writer is receptive, intuitive, with good imagination and
the ability to improvise. Having responsibilities and making
strong decisions are not their best qualities. They have difficulty
in explaining themselves or in getting involved, and are
dependent on their environment.

On the other hand, writers such as this can be tolerant and a
pleasant companion and partner. They generally experience few
mood changes. At work they are pleasant, efficient and good
negotiators. They have a conciliatory personality.

Inhibited movement

The writing looks as if it fears to progress across the page. It is held back and controlled by apprehension and uncertainty. There are false connections and suspended letters. The stroke is usually fragile and the pressure is light. The writer is modest, controlled and reserved. Such writers can sometimes appear anxious.

> This is a book dedicated to the style and design of the car from the eve of its invention, the style icons that have come into creation since the combustion engine got on the move, and looks forward to the cars of tomorrow and the designs that are shaping them.

Controlled movement

A well-organised and controlled writing with a steady baseline and supervised progression. This type of writer is conscious of their responsibilities. They are hard-working and vigilant, and usually restrained and reflective. There exists a developed sense of personal, professional and social responsibility.

> Through torrid afternoons, entire populations will present themselves before you, their hands raised in applause, their eyes wide open to catch a lasting memory of the battle. In the evening, as nature slumbers peacefully, tired after the long day, the peasant, burnt by the sun, will fall silent to celebrate your passing. Then, after the pain, honour will follow; alive again, you will enter Paris in sporting glory. And later, you will remember your exploits at the Tour de France, and you will be able to say with pride: 'I was there'.

Flowing movement

Here the writing flows without constraint. It progresses freely across the page with supple use of space and of the baseline. It is usually right-slanted, with curved connections, medium pressure and a gentle regularity, indicating good control of movement. The writing is often 'conventional'. There is nothing excessive in this type of writing.

The writer has a supple and open mind. Their convictions, while firm, do not create barricades. Practical sense, logic and method guide their judgment. The general attitude is progressive and the writer is a well-adjusted individual. There exists a resilient personality with healthy resistance to hardship.

This type of movement is seen mainly in active and well-adjusted adults. It is never found in people suffering from mental illness or in children.

Language and culture, political risks, incoterms, letters of credit, documentation, foreign exchange and international banking are just some of the features of export credit which make it so different from home trade.

Vibrant movement

This is a delicate writing, progressing in small vibrant groups, discreetly and without fuss. The movement is fine rather than forceful.

FOE OF BANAL MODERN ARCHITECTURE, VENTURI WAS BORN IN PHILADELPHIA AND STUDIED ARCHITECTURE AT PRINCETON UNIVERSITY. IN THE 1950s HE WORKED FOR MODERNIST ARCHITECTS EERO SAARINEN AND

The vibrant movement shows a great sensitivity and curiosity of mind. If this writing is also rhythmic, the writer is supple and modest. They have the ability to bounce back. At work, they tend to be conciliatory, although they may be neither exactly for or against the organisation or the way things are managed. They are vigilant and tend to stay young in their attitudes and/or near young people. They are often good in jobs that involve research.

Dynamic movement

The writing is energetic and aggressive, firm and progressive. There is vivacity and speed in this movement. It is an autonomous writing with right slant and strong rightward projection. Flying strokes appear regularly. These movements are efficient, confident and rapid. The words are often wide and connected. There are long lower extensions. Pressure is often heavy and the writing firm.

 The writer has active and rapid perception of situations. Their response is confident and usually quick. They probably have strong opinions and set ideas. This type of writer is better suited to a position where their dynamism, spirit of enterprise, and taste for action will be put to best use. They have the ability to create objectives and to achieve them.

Propulsive movement

There is great spontaneity in this writing which throws the movement towards the right with speed and vivacity. This type of writer has an impatient outlook.

There is always strong emotion indicated in this type of movement. Impulsiveness, impatience, imagination, passion, activity, dynamism and ambition are all common characteristics. There is excitability and combativeness too. The reactions are quick and often intense and there is a tendency to exaggeration, but also creativity and a spirit of enterprise.

Obstructed movement

The progression of the movement towards the right is obstructed as if by obstacles. The writing seems to be moving against the current and its energy is concentrated in combating it. This is an intense writing. The strokes are vertical, prolonged, and of precise direction.

I would enjoy going to Ireland for my holidays, where there is a remarkable Zoo.

The writer is self-motivated. They have conviction and a need for success. They invest a lot of energy in whatever they undertake. They stand up to their responsibilities with courage and affirmation. They have strong principles and a general attitude that is usually 'against' rather than 'for'. They need convincing, as they do not easily accept the point of view of others. It is important to them that their judgment is good.

Specific movement

Sometimes we can notice unusual movement within the
handwriting. This can be very revealing but, as with all
handwriting characteristics, must be taken in context with
other presentations and indications on the page and not used in
isolation to identify a person's inner mind.

Capital letters in the middle of words
This usually indicates lack of judgment and a tendency to
exaggeration. It is a sign of simple disorderliness and messiness.
The writer is not concerned about the right order of things and
may be economical with the truth.

ITS NACURAL, It's Healthy, AND It's EAUSO
ESSANTAL TO Any wall-WA OFFICE. PURE
WATAR, ata innovative NORWEGIAN COMPANY
<lats Fitters AND Chills ata MAINS SUPPLY.

Lassos

Lassos are formed by a horizontal flying stroke, curving and returning, so forming a large loop and a bow, or two large loops in one stroke. The presence of lassos in handwriting can, on the one hand, represent imagination, inventiveness and commercial talents; on the other, it can show selfishness, authoritarianism, and stubbornness.

Yours sincerely

Michael Portillo.

Final strokes

This refers to all strokes appearing at the end of a letter, word or line. If the final stroke is sharp, pointed and short, it may indicate a sharp, penetrating mind or an inclination to criticise. If it is long, it shows aggression and impulsiveness, particularly if repeated and frequent.

- If the final stroke is clubbed it may be favourable where short.
- If it is long, it can be either a sign of brutal and violent behaviour or a sign of generosity (depending on the supporting signs).
- If the clubbed end descends, it may show severe depression, which is not necessarily manifest.
- A final stroke turning unexpectedly leftward (such as the letter 'i' written 'j', or similar tails to the letters 'n' and 'p') indicates egoism, secretiveness and, when consistently repeated, mistrustfulness.
- An open final stroke in the form of rising garlands indicates suppleness of behaviour or captivating behaviour.
- Vertically prolonged final strokes, as used in the letter 'd', can relate to strong instincts, activity or materialistic interests.

Hooks

These are tiny little superfluous strokes, which usually appear at the beginning of an initial stroke of a letter or at the end of the final stroke of a letter, word or line, forming a pointed angle with the rest of the initial or final stroke. Interpretation is variable and depends solely on which zone they appear in, which way they point and how long or visible they are.

- Hooks tend to indicate tenacity and resistance.
- For the upper zone they show that the writer has fixed views (usually of an intellectual nature) and remains inflexible.
- For the middle zone, the stubbornness is more in the general attitude of the personality. Such types will not give up. They stick to their own feelings or activity.
- Hooks in the lower zone are usually unfavourable. They show a passion for material acquisitions and an attachment to possessions. There is a love of money. The writer may be aggressive, vindictive or selfish. Together with other signs, it may display dishonesty.

Initial movements/starting strokes

Where initial strokes do not exist, this form of writing is known as simplified writing. The writer has a quick mind and would be expected to have an immediate grasp of the essentials.

- Animated writing, where the initial stroke is curved, slightly rounded or enlarged, indicates talkativeness and/or playfulness and an optimistic temperament.
- Letters beginning with a rigid, ascending stroke demonstrate a spirit of opposition.
- Bad taste or vanity is demonstrated in complicated initial strokes.
- An initial resting dot indicates slow thinking or meticulousness.

Shark-tooth

A supported form of connection, this appears in the middle zone, usually in the letters 'm', 'n' or 'u' in their angular form. It is an indication of an instinctive, cunning ability. The writer is sly in their negotiations, artful and agile in their affairs. It is considered one of the signs of insincerity.

I give permission for this handwriting sample to be used in publication.

Spirals

Spiral movement is a centripetal or centrifugal movement – a curve which starts from a central point and turns around itself, enlarging like the shell of a snail. Centripetal movement travels in towards the centre – centrifugal travels outwards from the centre. This sign appears mainly in capital letters, although it can also be present in some small letters such as 'c' in the initial and the final strokes of the middle zone.

- There is a general desire to attract attention and interest.
- Other interpretations include exaggerated egoism, lack of equilibrium between the self and society, a need for possessions, and selfishness and vanity.

Strong regressive strokes

An intensely regressive movement of the stroke, with the pen moving upward towards the left and curving down in the form of a reverse arcade.

- Whether in the lower zone 'y', in the middle zone 'g' or in the upper zone 't', this sign shows egocentricity as well as a wish to monopolise. The writer has little sensitivity for other people's feelings or needs.
- If the end of the regressive stroke is also sharp-pointed, it shows hurtfulness, meanness or nastiness.

Twisted strokes

The down strokes which normally appear straight are distorted.

- This sign appears generally during periods of transition, from childhood to puberty to adulthood and, in women, during menopause.
- It can indicate nervous, glandular or circulatory disturbances which occur during these particular periods in life.
- The libido can be in regression or blocked.
- Overworked individuals often produce this sign. It is a sign of emotional upheaval, often temporary.
- It is also a sign of instability, great sensitivity and nervousness, or an unsettled period in life. Tiredness is the result of all such situations.

Speed

The speed or personal tempo of the writer begins to gain fluency at school when schoolwork increases or whenever note-taking is required. A quick script, though not a hasty one, must develop without the loss of legibility. Here we examine what writing speed says about an individual.

The speed of writing

Everyone has their own tempo, but emotional upsets will affect our writing. When a person's temperament is lively, then more discipline is required to maintain a positive, regular rhythm.

The mature, intelligent writer moves along the line, saving time in straightforward, graceful movements, individually creating their own shortcuts, thinking of the subject matter rather than the style of writing. The speed assessment reveals the spontaneity of the writer, plus their sincerity. Do they really mean what they are saying on paper?

A naturally slow individual would not write intelligently and legibly if they tried to write faster than normal. It is therefore the writer's natural speed which counts.

Consider an individual suffering from a physical disability which slows down their movement and consequently their writing tempo. Intelligence would still show in the originality of the script, as would their sincerity in the simplicity of the formation of the letters, which may, in recognition of the disability, produce a shaky stroke quality with a loss of pressure.

Those suffering from dyslexia will also write slowly, through hesitation, which will show in the form of frequent pen lifts from the page and reversed letters or misshapen numbers – a characteristic of the condition, but by no means an indication of a lack of intelligence or maturity.

The spontaneity which goes into a script is commensurate with the amount of energy the writer applies to their everyday tasks and with their inner resources, which drive them to greater activity through ambition and enthusiasm.

Writing speed and its meaning

Speed can be categorised under several different headings. Some of the more significant groups are as follows:

Accelerated

Writing at the rate of approximately 150 letters per minute. While this demonstrates adaptability and the capacity to accelerate the rhythm of work, it can also reveal agitation, messiness, illegibility and disorganisation.

Controlled

The writing is neat, regular, simple and usually angular. It is an indication of prudence, reflection and a sense of personal, professional and social responsibility. The writer will only make a decision having examined, analysed and scrutinised all sides of a problem. However, it could also indicate stubbornness, fearfulness and inhibition.

Poised

The writing is executed without haste, i.e. slowed down. The writer is calm, has a good sense of control, and possesses reflective rather than impulsive intelligence. On the other hand, there may exist a lack of willpower and docility. Such individuals may be sweet and sociable, but are also negative and unlikely to change the world. The famous French graphologist, J. Crepieux-Jamin, described such writing as a poor virtue and a virtue of the poor.

Flying strokes

The writing is impulsive, possessing rapid movements, leading to exaggerations. The prolonging strokes mainly occur in capitals and T-bars, and extend high above the upper zone. The writers are very active, impulsive and usually possess a feeling of superiority. It could, in certain cases, reveal a violent nature.

Slow

Fewer than 100 letters per minute. It demonstrates tranquillity, inactivity and slowness. The writer demonstrates self-control, reserve, modesty and an ability to analyse and classify situations. A resigned nature exists, with a lack of initiative and courage.

Effervescent

Very irregular direction and dimension. The strokes are jerky and agitated. The writer is active, intelligent and has deep sensitivity. However, impatience, inconsistency and self-indulgence are never far away.

Tension

Tension in handwriting represents a constraint, a resistance, a pressure, an effort. It also represents the degree of impatience towards reaching a goal. Tension is a component of the dynamism and the structure of the writing, and as such it can tell us about the personality of the writer.

Tension in writing

Although all writing has a degree of tension, it is rare that this degree will be present all the way through. In the majority of writings, many different degrees of tension exist.

Slack writing

In slack writing, the tension is weak. It lacks adequate stiffness or firmness. It has very little rhythm or structure.

The writing shows little of the structure of the personality. It lacks consistency, weight and definition, indicating a person who saves energy. Without strong convictions, the person is dependent – their level of consciousness is not high. The writer adjusts to the needs of the environment and often gives in through lack of determination or resistance, and through discouragement.

Dear MG,
I really hope you can help me. You see, I'm looking to get my hands on a certain poster which was featured in the background of one of your photostories. It's a poster of Peter Andre sitting on a motorbike, it's black and white. He's wearing a white vest and black trousers. I would really like a copy of it and I'm willing to pay. The photo story was 'My shocking secret.' 'I tested my boyfriend's loyalty.' August 1996 issue. Frame 30 (picture/photo 30). I hope you can help me or put me in touch with someone who can.

Thanks

Supple writing

A slight firmness gives this writing body without depriving it of its fluidity. It is relaxed and comfortable. The pressure is never very strong and the direction is supple, i.e. not stiff. The writer has good contact with reality. Their energy is channelled. Individuals who write in this way are laid back and never seek to complicate their own or other people's lives.

Firm writing

This writing combines suppleness with tension. There is slight stiffness. The movement has a controlled freedom and it is usually a sign of resolution and firmness. There is often a mixture of angles and curves to it.

Firm writing indicates a happy, blended personality that is controlled, with a quiet determination together with well-channelled energy. It shows independence, willpower and good balance between instinct and reason. The writer is in control of their abilities. They are mature, responsible and disciplined.

Taut writing

The movement, continuity and direction lose their suppleness and their progressive look. The writing is held back and a certain stiffness sets in. Pressure becomes heavier, the forms become angular, narrow and with arcades. There is evidence of form over movement, and of resistance to inner obstacles. This kindles adaptability. The writer is preoccupied with resistance and mobilises their energy excessively in an effort to overcome obstacles. There is little or no elasticity in the writing, whether it is straight or curved.

This degree of tension is found in people with a strong personality, who are strong-willed or obstinate, energetic and combustive, who rely only on their own abilities to achieve their aims. These individuals cannot relax. They are always anxious and pressured.

The stronger the tension, the more the writer is dissatisfied and stressed in their relationship with the world, and the more difficulty they have in affirming their own personality. They are rigorous and vigilant.

The stiffer the writing, the less is the writer's resistance to frustration and the more they turn in on themselves.

Over-taut, stiff, rigid writing

Excessive tension is marked by general stiffness. There is rigidity and/or mechanisation of the movement and the forms, or lack of communication through the irregularities that give a splintered look to the writing. Jerkiness, stiffness and starkness impact the continuity of the flow.

Over-taut writing often indicates anxiety. Individuals with such tension in their writing can have great difficulty in mastering their inner conflict and their emotions. They like to see a world bounded by their rules, of which they are in control. It is often the handwriting style of head teachers. Over-taut writing style is also a symptom of people who adopt stereotyped behaviour to mask their feelings.

Welcome to Bollywood! This is studio city, a fantasy fodder factory, the Bombay-based film capital of the Indian subcontinent. Here every year the Hindi film industry pumps out twice as many pictures as Hollywood to satisfy the romantic cravings of its billion-strong audience, from mobile-toting middle classes who sit in the air-conditioned comfort of big city cinemas, to the villagers transfixed by dancing images flickering on a dusty courtyard wall.

Over-taut, irregular writing

Irregularities in the quality of the stroke and consequently
in the tension, produce excessive and uncontrolled gestures
in the writing, which can be jerky and animated. There is a
lack of rhythm.

The writer has little control over their relationship with the
world and with reality. They can border on extreme abnormality.
This type of writing, however, is quite rare.

Pressure

Pressure in handwriting reveals an individual's self-image, physical vitality and stamina. It is produced by the fingers pressing the point of the writing instrument into the surface of the paper. The deeper the writing cuts into the paper, the deeper the reservoir of drive and energy the writer possesses.

Levels of pressure

The type of pressure employed by a writer determines the quality of the stroke, and this stroke will be unique to the individual.

Writing pressure is a complex phenomenon. Careful observation and study are required to determine the effect of pressure on the thickness, darkness, sharpness and shading of the stroke. Like all other features of writing, it is basically determined by the personality of the writer, and not by the tool they employ. Whether using pencil, ballpoint or fountain pen (except for superficial differences in the writing that identify the tool rather than the writer), the writing is always recognisable as one individual's unique expression.

Handwriting pressure varies from individual to individual, but can be grouped into one of three broad categories: heavy, medium and light.

Heavy pressure

Just as heavy pressure leaves a strong impression on the paper, so too the writer 'leaves their mark' on the environment. Individuals who write using heavy pressure are usually forceful, productive and want to make their mark on society. They possess considerable determination and endurance. Their depth of emotion and aggressive spirit are above the average. There is a vitality and strength that underlines everything they do or say. This intensity of spirit requires release. Often they will be 'outdoor' types, releasing pent-up energy through exercise or sports. The deeper the pressure, the deeper the passions: not just sexual energy, but passion for life, travel, challenge and adventure.

Mimi was getting dressed when she got into a bit of a muddle... "Oh no! My button's missing!" Where can it have gone? Follow the runaway button as its spins through Mimi's house – trekking the tail of Jasper the cat.

The risk-takers, the movers and shakers, the leaders in their field (science, politics, business, etc.) will write with a force and dynamism that spells passion. However, such individuals also tend to be set in their ways. They are averse to making any changes they consider unnecessary. Statistics indicate that they usually stay in a marriage longer than people exerting medium or light pressure.

A small number of people produce extra-heavy pressure: usually a sign of great emotional tension. Too much pressure on the paper means too much pressure on the individual. Strong feelings of fear, anger or the stress of competition will put their resources on notice, ready to take action, even perhaps when none is needed. Impulsiveness and a wasting of energy will take its toll on the health of one who writes with an extra-forceful or domineering hand.

Medium pressure

Those who write with medium pressure possess the same
positive drive and determination as the heavy-pressure writer,
but not in such great quantities. Energetic and resourceful, they
have the ability to see a project through to completion. The
writer who exhibits medium pressure may not want to run the
company, but would be a great asset to any committee or team,
as they can adequately shoulder their share of the responsibility.
There is a vibrancy and dynamism to their spirit that, when
inspired or motivated, says 'all systems go'. They recognise that
body and mind work as one unit. Rarely will they overextend
their energies to the point of depletion or exhaustion.

Early Japan was a land filled with internal strife and
warfare. Samurai tells the story of the courageous and
highly-disciplined fighting men of this time, showing
how they developed from the primitive fighters of the
seventh century into an invincible military caste, with a
fearsome reputation. It starts by looking at the samurai's
place in Japanese history where they were involved in
power struggles between the Emperors and the military
leaders (shoguns). There is detailed commentary on the famou
figures and samurai that led Japan during these volatile

An individual who writes with less forcefulness is able to change direction easily. The writer who possesses a light, flexible script is more adaptable by nature. Not averse to change, they may switch jobs, living quarters, or even partners. Light-hearted and easy-going, they are quick to forgive shortcomings, flexible enough to accept a last-minute change to plans, and accommodating enough to settle for quick compromises.

However, although quick to adapt, their energy and reserves are short-lived. They quickly evaporate when forced into long-term or overwhelming projects. They may become moody or take short cuts in an effort to see the task completed quickly. When forced to remain in a stressful environment, they become tense and withdrawn. Their gentle nature needs nurturing and care.

Light pressure

The light-pressure writer has more mental than physical
energy and is more often a thinker than a doer. However, their
flexibility and ability to accommodate other viewpoints give
them tremendous mental agility.

Extra-light pressure is usually evidence of anxiety, not to be
confused with tension. Tension is positive, in the sense that it
arouses a feeling of being ready to act and usually arises under
the stress of a deadline or important event such as making a
speech, taking a driving test, meeting a new boss, etc. Tension
will subside when the circumstances causing it cease to exist.

Many styles of architecture have been explored by Americans over
the years since the first European settlers landed on the East Coast.
For centuries we have been building houses that not only
protect us and offer security but also help define our
individuality.

Anxiety, on the other hand, is a constant undercurrent of worry
or apprehension – an edgy feeling of insecurity that interferes
with concentration, yet is not pinned to anything specific. It
never seems to let up, even when the project is completed or the
deadline met.

Changes in pressure

Some writings may seem to have erratic pressure patterns
that alternate between light and dark. When someone cannot
maintain a steady pressure, they lose motivation, succumb to
periods of fatigue and take the path of least resistance. Physical
and emotional reserves work together in a delicate balance and
the writer must plan for proper nutrition and rest to keep their
spirits positive.

 Changes in pressure may signal a change in physical or
emotional balance. On occasions, it may even be a sign of a
medical problem.

I would enjoy going to iceland.
AKaranla

Pastosity

The Hungarian graphologist Dr Klara Roman identified the term 'pastosity' to refer to a 'pasty' appearance in the writing, which is sometimes indicative of overindulgence of the senses. This can be good or bad, depending on the form level of the script. Many gourmet cooks, fashion designers and artists have this in their writing. Sensual sometimes to the point of intemperance, the pastose writer reflects their feelings in their style of dress, speech, occupation or hobby. Their work stems from sensual gratification. In pastose writing, the loops may look 'flooded' or closed, and certain formations may look extra thick.

In a negative writing, blobs, smearing and crossings-out indicate an overindulgence of sensual gratification by people who have become totally absorbed by their own experiences. Their language is usually colourful too.

Sensuality

In addition to handwriting depth, as seen in light, medium and heavy pressure, writing also has a definite width – fat or thin. Handwriting width, the richness of the line itself, reveals a propensity to explore and appreciate depths of character. It can reveal the extent to which an individual will go to gratify the senses, but the richness of the line itself will indicate how rich or starved are the senses. The same brain that transmits energy patterns also encodes messages from our senses of sight, sound, touch and smell. These neurological messages are transmitted through the pen, allowing handwriting to record our sensual impulses.

It is false to believe that the choice of pen solely determines line depth and width. The passion of the writer determines whether the line will be strong or weak, rich or sparse. An individual who deliberately selects a pen to create a rich, full-bodied line could be expressing a desire for sensual pleasure. Fountain pens and soft fibre-tip pens enable the writer to add force, vitality and a shading effect similar to an artist's brushstroke.

Individuals who write with heavy pressure or a sensual line often struggle with their weight (depending on the discipline in the writing).

Form and Continuity

The way handwritten letters are formed and connected to one another is very revealing to the graphologist. The shapes of the letters, and whether the strokes are connected or disconnected, can reveal much about the personality, imagination, ideals and character of the person who created them.

Letter formation

Four important examples of types of formation and connection are angular, arcades, garlands and threads.

Angular

Think of the letters 'm' and 'n'. Written with strong, firm angles, 'M' people are persistent and decisive, with intellectual ability and self-discipline. They are definite and dislike compromise. They excel at jobs demanding constant attention to detail. Negative characteristics can include aggression, possessiveness, obsessive tendencies and a rigid approach to life, with little flexibility.

Arcades

The arcade is in the form of an arch, closed
at the top, as in the letter 'm'. The writer
is closed to the outside with a reluctance to
allow the emotions free expression, and as a result may appear
cold. Formality and convention are the order of the day.

clock at Selfridges. We went to the
ASK restaurant which is off Oxford street. F1.
We talked a lot and enjoy the meal.
After we walked down Oxford street
and looked in all the shop windows as we
Passed them. They were a lot of people around.

Garlands

Here the bottoms of the letters are curved like a cup. Garland writers are open to the world. They are at ease and prefer to be with others of their type. Conflict is far from their mind as they tend to take the line of least resistance. Being sociable and caring, they are often to be found dealing with children.

No cuisine is based solely on its indigenous produce - especially not a country such as Britain, which, as a group of islands, was always open to invasion. Such invaders brought foods from various parts of the world, slowly introducing new meats, fruit, vegetables, herbs and spices to (what they considered) our rather plain food

Threads

The connection between the letters appears to be like a piece of cotton and the writing can be described as diminishing. It is often caused by haste. There is an economy of effort and those who have difficulty in writing or are simply lazy tend to produce this script. Such types rely on instinct, need scope for freedom, and have the ability to improvise solutions and discover opportunities. There are indications of an agile mind which prefers to learn by experience.

Its like wanting a birthday card F66
or a letter, you sit down to think
What Should I write? Maybe what

Continuity

The continuity of the writing refers to whether or not the individual letters within the same word are connected to each other. It assists in determining the writer's thought process. Different attitudes are reflected by those who connect their letters and those who don't.

Connected
Such writers express deductive thinking and good co-ordination of ideas, and tend to think before they act. They are usually sociable and have a need to belong. A good memory is often an additional facet.

I know that you won't read this, but will only analyse my writing style, so I don't suppose that it matters exactly what I write, be it sensical

Disconnected

Disconnected writing is where no more than three letters are connected together without a clear break. Disconnected writers tend to possess intuition and often act on impulse. If they are proved wrong, this is often of little consequence to them, as they are great justifiers of their own actions. The tendency to complete one letter before moving on to the next reveals a need to analyse every detail, even if it means losing sight of the whole.

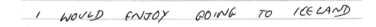

Grouped

Between the extremes of connected and disconnected, there is a further category, known as 'grouped' writing, in which letters are connected in small groups. Grouped writers possess intellectual adaptability. They know how to combine logic and intuition and can adapt to what is the norm, at the same time being amenable to new ideas.

Slant

The slant (direction) of an individual's writing is an indication of the writer's emotional responsiveness and involvement. To make a valid assessment, it is important for the graphologist to know whether the writer is left- or right-handed. Scant attention is usually paid if the slants are of a minor nature. But it is important where the writing is rigidly vertical or has a pronounced slant.

Variations of slant

How far forward or backward your handwriting slants indicates whether you release energy outwardly towards others, or inwardly towards yourself. It does not reveal what emotions you may be feeling, but rather how quickly they will surface.

Vertical

The more one's writing slants forward to the right side of the page, the more the writer is future-oriented, willing to take risks and make their emotions visible for all to see. Vertical writing forms a 90-degree angle with the baseline. When letters are written at an angle scarcely more or less than ten degrees from the 90-degree position, the slant is not considered significant. The more upright the writing, the more likely the writer is to pull back, to resort to logic and control.

> Creative ways to experiment with surface effects — on paper with drawing materials, paint or collage; on cloth with paint, dye and photo transfer; or with unusual materials such as plastics and metal.

Assuming right-handedness, vertical writing signifies a person who cannot relax in company and appears not to fit in with the group. Being dominated by reason rather than emotion, they would be expected to cope well in an emergency. They should demonstrate good self-control, prudence and restraint. Some might say there is a deliberate attempt to assert themselves and preserve a certain distance from everybody else.

Right slanting

Extroverts are good communicators, putting stress and importance on an external object and continually relating to other people and forming many relationships. Individuals with a forward or rightward slant to their writing are characteristically outgoing, friendly and ambitious, sometimes ruled impulsively by emotions rather than reason. There is a willingness to share experiences and thoughts.

I give permission for the above sample to be used in PRC's "Beginner's Guide to Graphology — Analyse This"

Extreme right slanting

Those with an extreme forward slant to their writing are usually highly strung and stubborn. They must always keep in touch with events and people around them to alleviate loneliness. There is a definite desire to attract attention and to be loved. They may well try to force their opinions on others.

It was the best of times, it was the worst of times, it was the age of wisdom, it was the age of foolishness

Left slanting

Leftward slant writers (writing with their right hand) tend to be introverts. This usually relates to past experiences rather than their future expectations and may indicate a 'mother tie' attachment. Introverts value the inward side of experience more than the outward side. They feel awkward and uncomfortable in a group, but any close relationship will have deep roots. It may take a long time to make friends but, once made, they will remain good friends for life.

Just because your granny is old
doesn't mean she can't have fun!.
This granny is bursting with
energy — in fact, it wasn't until

If the left slant remains slight and near the vertical, it means little. It is when the slant is markedly towards the left that defensiveness appears. Occasionally one finds a left slant in firm and dynamic writing, usually in individuals with important professional or social responsibilities. They find a way not to be too influenced by personal subjective aspects of their emotions, beliefs and motivations, in order to divert tension towards their objectives. This also occurs in small, sensitive and simple writings which, in this way, indicate reserve or even self-suppression.

Young people, often a little fearful of their future and of the outside world, sometimes experience this type of defensive vigilance.

Extreme left slanting

An extreme leftward slant, together with heavy pressure,
indicates opposition to almost everything where communication
and social contact are concerned. The writer will usually be
antisocial, awkward and with few friends – one who could be
well advised to remain single.

Variable

Writing with a variable slant reveals a personality that is
quick-changing and unpredictable. The writer may be pulled
in all directions. They are torn between introvert needs and
extrovert urges! Sometimes outgoing and sociable, sometimes
withdrawn and inhibited, they are often neurotic and unstable.
Energy is dissipated by inner conflicts, resulting in difficulties of
concentration and seeing a job through to the end.

The dinner party

To look at slants in more detail, we need to examine the chart below to ascertain the meaning of the variable slants.

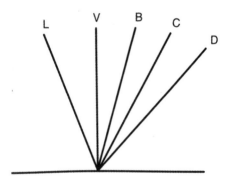

Imagine you are holding a dinner party for five guests and each guest's writing demonstrated one of the above slants. How would the evening progress? Who would project themselves and at what point in the proceedings?

You open the door, and **Mr D** bursts in with two bottles of wine, immediately makes himself at home, thanks you profusely for inviting him, and wanders around admiring all your possessions.

Over the next 45 minutes, the other guests arrive, duly taking up their seats around the table. (As expected, **Mr L** arrives last, a little awkward, much preferring to be in his own home and with you as his guest.)

Mr V waits for someone to open the conversation and to be asked a question. Then he is in full flow, expressing his fixed views and expecting everyone to listen to his every word and not interrupt. He has trouble verbalising his emotions, but he is a useful individual to have around in an emergency.

Ms B is more outgoing and demonstrative, so she is easier to get to know. Such types retain aspects of school-model writing. They have not deviated too far from the norm or experimented with different ways of expressing themselves. They maintain a balance between emotion and control. **Ms B** extends herself to others at the party without falling all over them. She is pleasant, serious, but not entirely head-ruled. During the meal she is likely to get trapped by the long-winded conversationalist, **Mr D**, as she does not want to appear bored or rude by pulling away too soon.

Ms B's emotions often influence her decisions. At the table she will plunge into a discussion without thought, and will probably respond to a request without thinking whether she is available when required. Priorities do not often take pride of place.

The next guest, **Mrs C**, being restless and impulsive, will jump into the conversation when she sees an opportunity to be controversial. She is strongly influenced by likes and dislikes. She

can become impatient and easily frustrated. If the conversation is of no interest to her, she will probably start playing with the knives and forks. Alternatively, she may try to start a conversation with one individual, probably **Mr V**, who will politely smile and say nothing.

Mr D is the extreme of emotional responsiveness. People with his slant on the world can lose perspective and react instantly without considering the consequences. They can become thoroughly absorbed in the mood of the moment, taking on another's problems as their own. During the evening, **Mr D** will search out these problems and try to solve them instantly, before forgetting all about it and moving on to something new.

Finally, you meet **Mr L**, who is likely to hold you at arm's length emotionally. This gives him a vantage point of control from which to operate. He needs to get a 'feel' for your personality before allowing you to advance too far into his world. He, not you, will decide whether or not you become friends. He will probably be the first to leave the party, having seen what he wants to see, done the right thing by attending, and happy living in his own world.

As the dinner party comes to a close, the guests will leave and continue to conduct their lives in their own way. You, the host, will remain their friend: your intuition will enable you to handle them each in the way they expect, because you are the person with multiple slants. You are versatile, impressionable and lively, with many interests.

Size

When you see someone's handwriting, you immediately notice its size – especially if it is particularly large or small. The terms 'large' and 'small' when applied to handwriting refer only to letters drawn in the middle zone. Abnormal length in the upper or lower zone extensions is simply termed 'prolonged'. The small 'f' is the only letter in the alphabet to have an upper, middle and lower loop occurring in all three zones.

Handwriting size

How large or small someone writes provides a good insight into their self-image.

Large

Distinguishing features associated with large-size script include vitality, enterprise, self-reliance and increased consciousness of the self. Excess of vitality will produce large script. Proof of this can be seen in the way the size of writing always decreases when vitality diminishes, for example with an invalid or elderly person.

Any writing in which the small letters are taller than 3mm is deemed to be large. Letters between 4mm and 6mm are deemed to be very large, and above 6mm is exaggerated. It is often to be found in the writings of people in the media and those who enjoy projecting themselves in the public eye. Such types find it difficult to concentrate for long periods and are easily distracted.

Medium

Medium-size script tends to be a sign of stability, adaptability and naturalness. Such types will see through any task they undertake.

With the price of equipment falling all
world of digital photography is now a
everyone who has access to a comput
technical jargen that surrounds the
early leave you feeling baffled and

Small

Small handwriting, where the small letters are less than 1.2mm in height, reveals a more modest appreciation of the writer's own importance. Individuals with small handwriting are often found in the area of research, science, mathematics, computers and other fields where concentration and exactness are necessary. Such types are capable of making judgments based on reason and objectivity. It may also reflect a lack of self-confidence.

The small writer with a copybook style of letter formation is usually using the style they were taught at school, with no originality. Such a person would be content to work in a very limited environment, where initiative and imagination are unimportant. They are content to follow directions and orders, rather than give them, and are followers, not leaders. However, a high level of performance can be achieved by the person who writes with a small script, as this person is rarely disturbed by outside interference.

From time immemorial, the tiger has been an ob
great awe, reverence and superstition. Its strength
ferocity are proverbial and it has an overpowering
It is deeply interwoven in the ancient folklore a
mythology of a number of countries, where it
symbol of bravery.

Capital Letters

Individuals believe that by writing in CAPITALS, their writing is disguised. What they don't appreciate is that certain idiosyncratic movements remain the same. The way a writer tends to form one specific letter may often produce a small unconscious sketch, design or symbol that is like a printed trademark. When you leave a sample of your handwriting around, you are leaving a view of your life for others to read.

The use of capital letters

A skilful and fluent writer is capable of producing copybook handwriting and getting away with it. However, a slow or semi-literate writer can never disguise their lack of education by writing in a quick and cultivated hand.

Anonymous letter writers

The anonymous letter writer forgets that speed, pressure, spacing between words, letters, lines and margins all reveal to the graphologist, with annoying accuracy, much about the writer's personality. When there are verified letters with which to compare the anonymous letters, then the culprit is quite easily spotted.

Case study 1 Care home

A large care home for elderly people asked me to examine a series of poison pen letters received by the home's manager.

The letters, written in capitals, accused various members of staff of ill-treating the residents. Initially I prepared an analysis of the handwriting of the perpetrator of the letters. I then compared it with that of a number of staff who had been dismissed in the last three years. From my description of the type of person who would have such a script, the head of the home immediately pinpointed a former member of staff.

I then looked at the individual's handwriting on file and confidently identified the person as having written the poison pen letters. When confronted, the lady confirmed she had written them.

Case study 2 Frank Abagnale

Frank Abagnale is a particularly interesting individual to study, having, by his own admission, been involved in fraudulent and dishonest activities for many years. He was the subject of the 2002 film *Catch Me If You Can,* starring Leonardo DiCaprio and Tom Hanks. It is the true story of a con man who bluffed his way into a series of identities and high-powered professions. But who is the real Frank Abagnale? I met him at a speaking event and, as I always do in these circumstances, asked if I could have a sample of his handwriting.

Born in 1948, Frank W. Abagnale's first criminal offence was to make purchases using his father's credit card and then sell them back to the original owners for cash. His parents divorced when he was 16 and, unwilling to choose which one he should live with, he ran away to New York, to a life of opportunist crimes.

He had soon defrauded people in every US state and in 26 foreign countries. Warrants were issued for his arrest all over the world. His ability to bluff allowed him to travel on one million free 'air miles' and to swindle unsuspecting bank customers.

When he was 21, an Air France flight attendant recognised him from a 'wanted' poster and he was arrested by the French authorities. He was imprisoned in France, Sweden and the USA for a total of five years. The USA sentence was for 12 years, but in 1974 the federal government offered him parole on condition that he helped the FBI, without payment, to understand the inner workings of fraud and confidence games.

Analysis of Abagnale's writing

The writer's signature is very different from his writing, indicating a lack of harmony between the writer's social attitudes and private reality. He lives in two different worlds, one of which is likely to accept dishonesty as a way of life.

The pressure of the signature is heavier than the writing, indicating that the writer's self-confidence is strongest when he is fighting for himself.

Overall, the writer is a driven and complex individual who is difficult to really get to know. He can be charismatic and charming when necessary, saying much, but elusive when he wants to be. The aggressive manner is coupled with a social charm, allowing his manipulation of others to get what he wants.

Shapes and Loops

The shapes and/or loops of the individual letters of the alphabet reveal much to the graphologist and could easily fill a book by themselves. In this chapter we examine some of the most distinctive and easily recognised features.

The shapes of key letters

There are three letters that are of particular interest to graphologists, both in their upper and lower case forms.

The letter 'F'
Some graphologists consider the letter 'F' to be the most revealing. It is the only letter that passes through all three zones. How you project your image and react to people is reflected in your 'F's.

The letter 'I'
The letter 'I' is one of the most important and revealing to the graphologist. It represents the writer's ego. It is seen as the mediator between the individual and reality. In English the ego symbol is one letter, the only language in which the 'ego' symbol stands alone. So in English handwriting, the way this single letter 'I' is formed is one of the most significant clues in an analysis and gives a real insight into the writer's personality.

The letter 'T'
The way the letter 'T' is formed allows insight into an individual's self-esteem, attention to detail and whether they are careless or conscientious.

The letter 'Y'
The shape of the 'Y' is regarded as having a link to attitudes towards pleasure, success and desire.

(top bar extended over whole word)	top bar extended over the whole word	protectiveness
	wavy	sense of humour, fun
	narrow	shyness, reserve
	angular	cruelty, madness
	cruciform	religious leanings, fatalism
	hook on starting stroke	avarice, greed
	club like, down-pointing top bar	unkindness, cruelty
	rising top bar	desire for self-improvement

Lower case F

	narrow upper loop	emotional repression
	full upper loop	articulate, open-minded
	lower loop angular at base	unwillingness to compromise, resentment
	triangular lower loop with horizontal end stroke	selfishness
	tick starting stroke, no upper loop	clever observer of people
	long lower zone	down-to-earth personality, love of outdoor sports, restless
	large upper loop, no lower loop	many ideas with little follow-through
	ink-filled	sensuality
	triangular stroke	needs to have own way
	knotted	toughness and thoroughness

Upper case I

I	single stroke	intelligent, straightforward, genuine nature
I	single stroke topped and bottomed	high opinion of self, confidence, clear thinking
∂	closed	unwillingness to compromise, resentment
4	similar to a number 4	overconcern with self
$_9$	reclining	unfulfilled desires
\jmath	unfinished starting and end stroke	poorly developed ego, dislike of people generally
g	over-inflated upper loop	exaggerated sense of one's own importance; a large loop is a sign of vanity and a very large loop is a sign of megalomania
ϑ	small and cramped	inferiority feelings, self-consciousness
g	upper loop complete, end stroke short	influenced by father

ꝑ	upper loop incomplete, end stroke extended to left	influenced by mother
ꝯ	pointed at top	penetrating mind
ꝯ	arc at left at base	avoidance of responsibility
ꝯ	enrolments	egoism, greed
ꝉ	triangular base with heavy pressure	violent nature
í	capital written as a smaller letter	a very immature ego
ꝯ	a very narrow letter	repression and inhibition

Placement of the solo letter 'I'

'I' and other capital letters of equal size The ego is equable.

'I' more elaborate than other capital letters Pronounced self-consciousness.

'I' fluctuates in size The ego is unsteady.

Lower case I

i (dot directly above)	dot directly above	precise, exacting nature
i (dot to right)	dot to right	impulsiveness, intuition
i (dot to left)	dot to left	procrastination, caution
i (dot omitted)	dot omitted	carelessness, absent-mindedness
i (dot high to right)	dot high to right	curiosity, impatience
i (arcade dot)	arcade dot	deceit, concealment
i (dot like dash)	dot like dash	hasty temper, irritability

(wavy dot over i)	wavy dot	sense of humour and fun
(club like dot over i)	club like dot	sensuality, brutality
(circle dot over i)	circle dot	desire for attention, eccentricity, feminine traits
(dot like arrowhead over i)	dot like arrowhead	sharp wit
(dot like tick over i)	dot like tick	ambition, desire for recognition
(dot connected to next letter)	dot connected to next letter	clever combination of ideas
(dot like vertical stroke over i)	dot like vertical stroke	critical nature, emphasis on principles

T

Upper case T

	top bar high and removed from the stem	indicates high aspirations which are not always followed through
	top bar like horns	stubbornness, obstinacy
	top bar convex	protectiveness; good self-control
	similar to letter x	uncertainty, depression
	top bar weighed down on the left like scales	wavering in ideas and actions
	top bar joined to the next letter	cautious; weighing up all pros and cons before taking action
	top bar extending over whole word	protectiveness; tendency to patronise; sense of humour
	wedge-shaped	always objecting and criticising
	top bar hooked to right	determination, greed
	wavy top bar	sense of humour

✕	falling to left	little respect for others
✝	cruciform	religious leanings; fatalism
✷	like number 2	inability to relate intimately, feels second class

Lower case T

∪	cross bar omitted	carelessness; absent-mindedness
⊤∪	high cross to left of stem	content with subordinate position
ヒ	short low cross to right of stem	content with subordinate position
⊤	long high cross to right of stem	leadership qualities and overall ability to control
✗	down-pointing cross	obstinacy, contrariness
✦	low cross through stem	caution; attempts to overcome feelings of inferiority

115

ᵗ	middle cross through stem	takes responsibility with great conscientiousness
ᵗ	high cross on top of stem	leadership qualities balanced with caution
⅂	like number 7	ruthlessness
ᵗ	double cross	compulsive need to check and recheck, possible dual personality
ᵗ	bent stem	neurotic tendencies; self-absorption
⌐	cross from base of stem	a quick, ready liar

Y

A long lower stroke belongs to an individual overconcerned with materialistic success and pleasure. They are dominated by their security needs and survival instincts.

When the pressure is fairly heavy, the writer will be physically active. A very heavy pressure will indicate that energy is being distributed into the sexual sphere, with little regard for the other areas of life. The fuller the loop, the greater the degree of fantasy a writer displays.

Where the lower loop is neglected, there exists sexual uncertainty and little active involvement, possibly due to fear of failure. There is also likely to be a low sense of self-preservation.

A long and tapered loop (usually written by males) indicates a firm, no-nonsense approach – someone who is always hoping for something new but will not admit to it.

A lower loop that turns to the right shows an interest in helping others.

An angular triangular loop shows aggression and obstinacy. It belongs to someone who is difficult to please, or who is frustrated through sexual disappointment.

Signatures

Handwriting shares a gestural character with the spoken language. Nowhere is this more dramatically evident than in the signature. The signature is a reflection of the attitude adopted by the individual in the face of the collective. Some say it is the 'psychological visiting card'. It is the most distinctive component of handwriting.

Displaying your potential

With the signature, the writer takes responsibility for what they have just written or typed. On a typewritten document, it becomes the writer's only opportunity to personalise their work and reveal themselves to the outside world. The impact of computer technology is so great that handwriting is used a good deal less than previously, but the signature has retained its importance. Beyond its obvious practical function, it is an expression of the individual and unique character of the writer, whereby a person projects unconscious images and feelings rich in meaning.

One knows little about the writer without the signature, as it is the key to the writer's real personality and inner life. An individual's writing shows their potential. Their signature indicates whether and how they use this potential. It is the expression of the official side of the personality and the face they show to the world.

It reveals their vitality, the direction they give to life, their ability to realise their potential, and how they put their abilities to use. It is their own evaluation of self, their personality, and how they see themselves in the public eye. It indicates the degree of the writer's spontaneity, morality and honesty. It also gives clues about the writer's family history, the summation of their childhood and personal history, the situation in the family home, and even how attached they are to memories of past events.

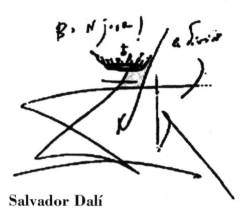

Salvador Dalí

Signing one's name is generally an important act, whether or not one is conscious of it. A signature is unique in that it reveals how you would like the world to perceive you, which is not necessarily how you really are. The signature is both an expression of the ego, with which it identifies itself deeply, and is representative of the social ego or the image of self which the writer, more or less consciously, wants to give to others.

The first thing a graphologist observes, apart from the general appearance of writing, is the first letter of a word. Just as the impression a person makes the first time you meet tends to be lasting, so the first letter of a written word indicates how a person is likely to behave when interest is focused on them. This is because the first letter of a new word is not connected to the previous word, leaving the writer free to move their pen in the way they consciously or unconsciously wants. And a signature, of course, is entirely disconnected from any other script.

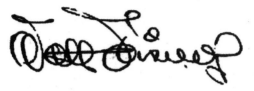

Walt Disney

One cannot expect to see the whole character of the writer expressed in their signature. An individual can be very different in their private life from their social and professional life. However, to the skilled eye, the signature contains significant clues about a person's strengths and weaknesses.

In modern society, the usual signature consists of three or four parts – the given name, middle name, family name and, in most cases, a final appendage. This may be a simple dash, or a terminal stroke. It may be a complicated flourish or a curlicue, or a characteristically formed jumble of lines. The signature may present an illegible configuration of slurred letters and embellishing strokes which the writer habitually uses as their personal device.

The graphologist will look at numerous points, including:

- Whether the first name is written in full or simply confined to an initial.
- The position of the signature on the page in relation to the text.
- Extras within the signature, such as flamboyant strokes and paraphs (see page 122).

The paraph

A paraph is a mark or flourish under, above or around the signature, and is very revealing. Despite the modern concern for simplicity, the paraph is still very revealing of an often subconscious tendency in the individual.

All marks and flourishes under a signature compensate for an inner complexity. A signature without paraphs belongs to someone who is natural, modest and discriminating. Someone who signs with both a forward and backward stroke has a dramatic instinct. Those who use a straight line continuing at either end of the signature are emphasising their ego, and if the line is very heavy, then they are bound to have an assertive personality. A small convex line under a signature indicates self-confidence, while strokes going both over and under the signature show persistence.

The person whose paraph covers the whole of their signature has a desire to dominate. And where the paraph encircles the name, this is an attempt at protection or to keep others at bay. If the paraph is in a lasso form at the end of the name or underlining it, this is usually a sign of a supple, adroit, diplomatic or commercially adept mind.

A centrifugal stroke preceding or following the signature and directed towards the right reveals physical courage and a generally aggressive attitude.

A stroke which moves in a downward direction and stops abruptly indicates the will to ensure material success.

Written in zigzag form, where it is angular and resembles a stroke of lightning, suggests a cold, vindictive and brusque nature.

Size of signature and legibility

One of the most obvious differences between signatures is their size. Some are small and cramped, taking up only a very small amount of the paper available to them. Others are much larger, sometimes taking up much of the paper.

A prime factor affecting the size of the signature is self-esteem. When the signature is larger than the rest of the writing, this indicates that someone considers themselves to be important. They believe that what they do or say matters, because it came from them.

Those whose signatures are completely illegible may be unconsciously protecting themselves or hiding something that they do not want the world to know. Alternatively, they may have such utter disregard for others that they do not care if their signature is legible enough for others to make out their name.

Generally, and in hurried circumstances, a legible signature reflects sincerity and an illegible one reveals unreliability and evasiveness. An irregular signature with a complicated structure indicates a complex personality, whereas a signature that is smaller than the text signals unconscious self-devaluation. A signature that is considerably larger than the text is a mark of autocracy. A signature that is similar in size and style to the text is an expression of modesty and sincerity.

Enlarged or oversized first letters of a signature usually indicate feelings of inferiority, with the writer compensating for their deficient self-esteem by emphasising their standing with an oversized capital letter.

On occasions, the capital letters in a signature are smaller than the other letters, usually implying self-devaluation. This can be confirmed by looking at the size of the capital 'I' in the script when used as the personal pronoun.

- Where the signature is taller than the text, this indicates that the writer is conscious of their own worth. If it is smaller than the text, the writer is showing modesty or a lack of self-confidence.
- A very wide signature is an indication of someone who is an extrovert and self-confident.
- An illegible signature shows that the writer is evasive and tends to avoid responsibility.
- If the first name is more developed than the surname, some say this shows a married woman who neglects the surname of her signature and reveals hostility towards her husband.
- A rising signature shows drive, ambition and the desire to get on. A falling signature indicates extraction or sheer obstinacy. And a final underline in a signature shows willpower.

Signature strokes

Strokes that extend horizontally to the right signify a defensive attitude. Signatures with strokes sharply angled to the upper zone show that the writer has an aggressive streak, whereas a gentle curve to the upper zone indicates generosity. Where the end stroke is made up of several curves, the signatory is an exhibitionist, but if the end strokes are jagged lines there is a sense of compulsion and determination.

Sometimes, where the writer is in a perpetual state of anxiety, the end stroke encircles the signature. If the last letter ends in a sudden curve, the writer has a forceful personality. A sudden flourish in the last letter means that the writer desires to feel important and may be trying to compensate for feelings of inferiority.

Letters within signatures can become numbers or symbols, for example 'g' becomes '8', 'T' becomes '7', 'S' becomes '$', and 'K' or 'L' become '£'. This phenomenon usually appears in the signatures of accountants, bankers or financial advisers.

Relationship between signature and text

Although handwriting alters with the development of character, the signature will usually remain close to its original form. This means that for most people their writing and their signature do not structurally marry.

In youth, variations in the signature are not considered important. But as soon as the individual becomes responsible for their actions and has to honour their commitments with their signature, the signature must remain constant. As an adult, it is important for the signature to be uniform, particularly when signing documents. So some people may retain an odd signature simply because necessity forced them to preserve the one they developed during the earlier part of their life. For instance, they may continue to include a paraph above or around the signature. This is an important feature, which can reveal the subconscious tendencies in the individual.

It is not unknown for people to be stuck with a ridiculous signature all their lives, simply because necessity forced them, in spite of themselves, to preserve the one they developed during their youth.

When script and signatures are clear and legible, individuals are generally at ease with themselves and feel no need to present a false front to the world. A small signature following a larger script tends to indicate underestimation of self, or may simply be based on a desire to appear modest.

If the signature is written in a style similar to that of the text, one can assume there is no difference between the writer's intimate self and the 'front' shown to society. But where there is a marked difference between the signature and text, it is a sign of a two-sided personality – of behaviour in public which does not correspond to the writer's inner nature. The former is reflected in the signature and the latter in the text.

Where a signature is placed centrally under the text, the writer has a natural modesty, displays caution, and has a desire for security. If the signature is placed to the extreme right, the writer is eagerly active and impatient. Signatures to the extreme left of the text are indicative of a state of anxiety and a strong inclination to escape reality. This is an extension of the characteristics of a writer who signs to the left of the text, who will have retiring instincts and a tendency to withdraw from society.

If the writer signs close to the text, they feel a strong bond with its contents, whereas a signature placed far from the text means that the writer, whether consciously or unconsciously, feels detached from the subject matter.

Sometimes signature and writing are so different that it is difficult to believe they belong to the same person. Many explanations exist for this condition. A logical one says that the writer experimented a great deal as a child and consequently developed an odd-looking signature.

It is interesting to note the variation between the first (given) name and the surname (family name) in many signatures. This indicates the direct expression of the writer's reaction to family ties and to parent/child relationships. In any signature, the family name represents the social ego, whereas the given name dwells on an inherent part of the ego. When both names are similarly written in the signature, this indicates a harmonious existence in both private and public roles. Overemphasis of the family name will usually indicate family pride or a feeling of prestige and preoccupation with status.

Such is the telling power of your signature that a graphologist can often get a good indication of the writer's qualities and character simply from looking at this single sample of writing. But it is a basic rule that one needs more than this to do a competent handwriting analysis, even though a person can reveal much about themselves in the short space of time that it takes to sign a name.

The Address

Whenever we receive a letter, our first reaction is to look at the writing on the envelope. Many of us try to guess who sent the letter simply from the writing. But we can also guess an aspect of the personality of the sender from where they locate the address.

Analysing handwritten addresses

The layout of the address on the envelope can be interpreted in the same way as the layout of the text on the paper.

- An address that covers the whole envelope reveals an obtrusive personality who has little consideration for others (a).
- An address that is cramped together in the middle of the envelope and surrounded by a vast expanse of white indicates voluntary isolation (b).
- An address that is placed very near to the top edge of the paper, with pen strokes slightly upward, is an indication of idealism (c).
- An address that is positioned very low on the envelope and is accompanied by heavy pressure or long lower zone projection is usually indicative of materialism (d).
- The address in the left half of the envelope shows prudent reserve and someone who usually likes to maintain a continued distance between themselves and others.
- If the address is pushed over towards the right, this is an indication of extroversion and spontaneous communication with others.
- The size of the envelope may force a writer to condense their writing or overshoot the margins. To be able to vary the layout and size of one's writing in accordance with the available writing area is a sign of flexibility and adaptability.
- On the other hand, to make alterations for no real reason reveals a degree of instability or a need for change and possibly an idiosyncratic nature.

a)

b)

c)

d)

Colour of Ink

The colour of the ink the writer chooses is meaningful for the graphologist. We all occasionally grab the nearest pen to jot a note. But if, for instance, you are handed a red pen to sign a cheque, you may say, 'I cannot write with that.' The deliberate choice of ink colour is an unconscious but definite statement by the writer of their attitude towards society.

Colour and personality

- Black is the sign of a leader, a demanding or forceful character, who wants to make an impression and is decisive.
- Light or dark blue indicates someone who is calm, trusting, dependent and with no desire to be exceptional or pretentious.
- Those using brown ink have the ability to keep a secret at all costs. It is used by people working in high security and also by artistic, professional people. (Through my work I met a group of retired UK government officials. One admitted to me that he had used brown ink throughout his working life. When I suggested that his occupation had been something of a secret nature, he said, 'That is as much as I can tell you.')
- Red writers are demanding, shocking, drawing attention to themselves.
- Use of green demonstrates an aristocratic nature or feeling of superiority, someone who likes to impress. (When this was discussed at one of my lectures, an individual told me that his wife always writes in green ink. He then said, 'She always considers herself above everyone else.')
- Purple is a colour preferred by the emotionally immature and the fashion-conscious. In men it usually reveals effeminacy; in women there is a love for high society.
- As for dual colours, the use of two or more colours in one piece of writing indicates egocentricity. Such types should be handled with the utmost care.

Doodles

Doodles are of particular interest to the graphologist. They are produced unconsciously on virtually anything that comes to hand. At least seven out of ten people doodle. In fact, they are demonstrating the boredom of the writer, who is usually waiting for something to happen.

The meaning of doodles

Intricate doodles are usually found at serious meetings. When someone is under pressure, the doodles become more and more involved, indicating uncertainty or insecurity. Repetition in doodles shows an impulsive character. Such types can be expected to speak their mind and tend to be easily irritated.

Repetitive patterns indicate discontent and possible obsessive behaviour. Such doodlers believe themselves to be the only person who can do a job properly.

Angular patterns reveal that there are underlying feelings of anger and that the individual is always happy to find something to be annoyed about.

Some psychologists see doodles as a projection of hidden emotions and they are often used in personality assessments. Everyone doodles in a slightly different way – and there are endless varieties.

Aeroplane Quickly drawn, with light pressure, this is a phallic symbol. But a slow, detailed drawing with heavy pressure shows a desire to escape monotony.

Animals Aggressive creatures such as lions or bulls show there is a desire to dominate and conquer. Less aggressive creatures such as cats or rabbits show a gentle type of personality, a lover of animals.

Arc A concave arc with heavy pressure indicates feelings of emotion, but a slowly drawn arc using light pressure and leaning to the left or right is a sign of uncertainty.

Arrow If more than half the arrow is quickly drawn, this is a symbol of male sexual energy. But slowly drawn, with heavy pressure and thick strokes, shows a cruel streak. An inverted arrow is a sign of penetration.

Bell This is a sign of conscience and a depth of feeling.

Boxes People frequently doodle boxes while sitting in meetings. As soon as they begin to join them up, you can be sure that within ten seconds they will speak. Something has aroused their attention and they need to comment.

Circle A perfectly joined geometric circle, executed with firm pressure, shows a desire for order, completeness and independence. A circle drawn with a flowing line that does not join, but ends curling over, symbolises female breasts and maternal influences. A slow, hesitantly drawn circle, using heavy pressure and joined with amendments, signifies anxiety and seclusion. Linked, quick, firm, small circles, moving to the right, show a reflective and logical sequence.

Clouds Drawn with light pressure, these indicate a desire to escape.

Crown Someone who naturally 'doodles' a crown is self-confident.

Dots Sequences of dots are a sign of concentration.

Eyes This shows the individual has a self-centred nature. If the eyes are detailed, including large lashes with pupils drawn in, this shows a flirtatious mentality. The doodler may well dress in a provocative manner, but would be astonished if an improper suggestion were made to them. Drawn with light pressure on the outer circles and heavier pressure on the pupil, this is symbolic of female genitalia. Geometrically and heavily drawn eyes show a need for protection.

Faces There is usually an intention to bring to mind those nearest and dearest to the individual. However, if the doodled face is angular, it indicates a longing for security.

Fence A round, stockade formation shows inhibition, while a geometric, firm formation indicates self-control.

Feet The foot doodler tends to be an earthy, passionate type, who is more direct than romantic.

Fish This shows a realistic approach to matters, the depth of which is indicated by the depth of the pressure and strokes.

Flowers These show a sentimental, romantic person: A circular flower with a linked stem is a symbol of the womb. More than one flower, quickly drawn and shown with some petals dropping, is a phallic symbol.

Frames A light, hesitant line without gaps shows that the individual is cautious. Quick, firm strokes with a well-constructed doodle inside the frame mean that the doodler is orderly and systematic. A frame with cross divisions inside shows a desire for protection and security.

Lines Horizontal and evenly spaced parallel lines, firmly drawn, indicate a mechanical existence. Lightly drawn vertical lines show the person to be reflective; weak parallel lines, drawn with light pressure and swerving downward, show a weakness of will. Angular lines drawn with heavy pressure indicate aggression, hostility and resentment. Complicated line patterns represent a defence against provocation. Heavily pressured, crossed lines are a sign of conflict. Closed crossed lines, drawn slowly, show feelings of restriction, and geometric crossed lines executed with light pressure show a conscious desire to keep impulses under control.

Shoes The shape of the shoe is usually sensual. A rounded top shows admiration of females, but the spiky heel reveals sarcasm (shown in the sharpness of the points). The heavy boot shows a desire to dominate.

Short strokes, marks and dashes Drawn aimlessly and with light pressure, these show emotional confusion, but with heavy pressure and drawn in a controlled way, they show a restless energy.

Snake A curving, flowing snake is a phallic symbol and shows passion. A snake that curves around into a coil, or is upright, shows achievement and understanding.

Square Quick, loosely drawn squares show a feeling of being trapped, squares with heavy pressure show materialism, and geometrically constructed squares drawn with heavy pressure show practicality.

Stars This is a common doodle. It shows determination, an intention to reach goals and possible aggression. A five-point star shows harmony and a six-point star is indicative of objective concentration.

Steps Drawn quickly and with heavy pressure, these are sexually symbolic, but slow and firmly drawn steps show ambition.

Stick people These are adult-type doodles. The sharp points indicate high intelligence with an analytical mind – someone who comes straight to the point.

Tick This is a sign of concentration.

Trees A rounded tree bearing fruit indicates a warm-hearted and friendly person. The weeping willow type of tree doodle shows the individual to be tired or depressed at the time of writing. The Christmas tree doodle, which is usually pointed, shows a sarcastic nature. Under pressure, this person will become aggressive. One tree standing alone can be a phallic symbol, and a group of trees shows developing thoughts.

Triangle Symbolic of male genitalia. Drawn with a firm stroke and heavy pressure, it shows the writer to be strong-minded.

Web An intricate design drawn with light pressure shows preoccupation with self. Thick, heavy strokes show anxiety.

Wheel This shows a dynamic urge.

Whorl In a right-handed person, drawn clockwise with heavy pressure, the doodler is mentally alert. Drawn anticlockwise with light pressure it shows repression. A tightly drawn whorl shows tension; a loosely drawn one shows the doodler is relaxed.

Famous Handwriting

To show how graphology can be applied in the real world I have taken a number of famous names, both from history and the present, and analysed their handwriting and signature styles. As seen in the chapter on signatures, the style someone adopts in the signing of their name can be quite different from their handwriting. The signature is the face we present to the outside world, whereas handwriting is a subconscious display of the personality.

Analysing historical figures

In compiling these analyses in some cases I have relied on copies of signatures, rather than looking at the original writing. As you will have no doubt picked up by now, the ideal situation would be to look at the written sample itself; that way the graphologist can fully appreciate the pressure applied on the paper. So, here are just a few facets of these celebrated men and women.

Admiral Lord Nelson (1758–1805)
Naval Commander

It is not known when the signature observed was written and with which hand. After he lost his right arm in battle, he was forced to write with his left hand. The signature indicates an individual for whom strategy, theory and principles are the ruling forces. Not only is he able to keep secrets but, when it suits him, he withholds information which ought to be made known. It appears that he may be able to substitute intellectual achievement for satisfying personal relationships.

The baseline's downward trend seems to suggest that he is feeling somewhat negative or perhaps fatigued at the time of writing. Overall, the horizontal movement and moderate pressure suggest the leadership traits of self-confidence, energy and activity.

The Duke of Wellington (1769–1852)
British Politician and Commander

The fact that the writing leans to the right, with no excessive ornamentation, indicates activity, determination and a good flow of thoughts.

The sharp, narrow points of the writing indicate his logical thinking from the left side of the brain. The light touch and fineness of the writing, together with its airy rhythm, indicate the intuitive thinking of the right side of the brain.

His intuition, enthusiasm and excellent reasoning powers can be seen through his even baseline that shows little fluctuation.

Napoleon Bonaparte (1769–1821)
French Commander

The writing and signature were executed in 1821, shortly before
Napoleon's death at St Helena. It has an uncharacteristically
delicate look, unlike other examples of his writing. It may have
been that this was a particularly difficult time for him, or that he
may have been ill.

 The rising baseline is a sign of one who is fighting against
depression. At the time of writing perhaps there was a slight
glimmer of hope for the future. The spacing suggests not
only that he is a loner, but that he has difficulty in putting his
thoughts together effectively. Being both intelligent and intuitive
increases the frustration, as shown in the heavy paraph.

Samuel F.B. Morse (1791–1872)
Inventor

The writing is organised and precise, with each letter written with effort – exactly how it was taught to him. It does not deviate, thus he is happy to conform to the rules of the society in which he lives.

The writing is of an educated gentleman of the 19th century. He is able to make clear judgments when dealing with problems encountered in everyday life.

The paraph (underlining) of the signature indicates that people attempting to deceive the author could awake a long-suppressed wrath. Overall, the writer displays confidence in himself and sincerely believes that he would succeed in almost anything he undertook.

Thomas Alva Edison (1847–1931)
Inventor

The writer's signature indicates strength and flexibility. He has
the capacity to make quick changes of direction and to try new
methods when old ones cause him irritation. In his signature,
some letters are connected, others are not, indicating that he
has fluid thinking. Thus he is unable to transfer his thoughts
instantaneously.

Alexander Graham Bell (1847–1922)
Inventor

The writing reveals a quick thinker with the ability to string together a series of concepts in logical succession. Clearly mundane activities paled into insignificance when he was involved in more interesting pursuits, such as working on his inventions.

There are indications of stubbornness, too. Stubbornness is revealed by the angular writing, which is firm, constant and precise.

Sigmund Freud (1856–1939)
Father of Psychoanalysis

The emphasis in the writing is on movement, manifesting an ardent, enthusiastic nature. Together with the angular connecting forms in the writing, this enables him to think on his feet and rapidly switch from one thought to another.

The dominant form in his handwriting is the angle connecting form, which indicates that he has to be the leader, the master in his relationships. Not one to suffer fools gladly, his impatience, seen in the very hasty speed of the writing, could potentially make life difficult for those around him. The thick, inky strokes are executed by an individual who could also be overly self-indulgent, allowing his own urges to take precedence over others' desires. He has to be in charge and would not easily follow orders.

Henry Ford (1863–1947)
Industrialist

Henry Ford's signature is probably the most famous in the world, appearing as it does on tens of millions of automobiles. The Ford badge is Henry's signature. His name is written quite speedily with a definite right slant, indicating that his intellectual abilities are always on hand to be used, unlike some intellectuals who are only capable of using their brain power in a narrow range of conditions.

Sir Winston Churchill (1874–1965)
Politician

Some might find it surprising that the writing is modest and unadorned. It is well arranged and balanced. The writer knows his own worth and feels it is not necessary to project his image.

 He is very much an individual and his best work is usually executed apart from others. He is capable of directing his energy to where it is needed at any particular time. The attention to detail in the writing indicates one who would be expected to carry out his promises and commitments.

Charlie Chaplin (1889–1977)
Entertainer

The spaces between the words are quite variable, sometimes quite close and at other times wide, an indication of sociable variables.

The handwriting reveals he is the type of individual who needs closeness and intimacy one moment and will then suddenly demand his own space.

John Fitzgerald Kennedy (1917–63)
Politician

The strongest aspect of the writing is the picture of movement, which reveals a vigorous, active individual who could not sit still for long at a time. He is capable of seeing the big picture and is not particularly detail-oriented. To get things done, he needs to have someone to follow behind him, handling all the administrative details.

The writing moves forward at a terrific pace, with letters appearing to fly off the paper, indicating one who has to be on the go the whole time. The sedentary life is not for him.

The long lower zone indicates strong physical drives.

Margaret Thatcher (1925–2013)
Politician

On looking at her writing, the central place of power-seeking in her personality is evident in the large capital letters of her script. This shows a need for recognition and a desire to lead. The spacing between the words indicates a clear determination to achieve success by her own efforts. She is action-oriented, but since her writing veers neither to the left nor right, she is unlikely to panic in a time of crisis. The writing is clear and precise, showing someone who keeps to the point. She combines practical planning with plenty of self-confidence.

Queen Elizabeth II (1926–)

This is a very disciplined signature. All the lines are carefully formed, showing her clear thinking and precision. She has the ability to concentrate her thoughts on one subject. The pointed letters are a sign of her intelligence. Her letters are narrow, suggesting she finds it difficult to relax.

The cultured letter 'E' indicates gentleness and refinement. The lower zone and the unfinished loop of the 'Z' reveal controlled emotion and in some handwriting this can represent sexual repression. Crossing her 'T' high shows her leadership qualities. She will not tolerate anyone going against her wishes.

Brigitte Bardot (1934–)
Actress

The combination of precise, straight and organised writing indicates energy in action. The circles and artistic streaks show her mannered style of self-presentation. That style also dictates her emotions. The closed letter 'O' with a line within shows not only her ability to keep secrets, but also an ability to withhold information that should be made known, leading her to mistrust others.

O.J. Simpson (1947–)
Sportsman/actor

The writing can be described as block-style printing and in this case it is centred in the middle zone. This signifies involvement in the present. The writer has little interest in what happened yesterday and is not concerned with planning ahead. Such a writer is a highly valued individual who focuses on what is going on at the moment and acts on it. He needs to be in the spotlight. He focuses on the practical needs of daily life, so he may have some difficulty seeing the big picture.

 The printing in a wide spatial arrangement suggests someone who wants to make sure he is absolutely clear in what he wants to get across and he insists on having the last word.

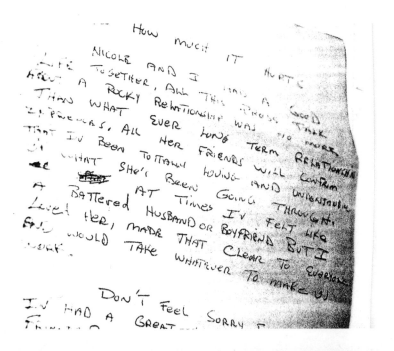

Hillary Clinton (1947–)
Politician

All non-essential strokes in the writing have been omitted, leaving only what is necessary for understanding and direct communication. This no-frills type of writing means you can count on her and that she means what she says. The short endings on many words and the abrupt breaks within words indicate that there are times when diplomacy is not in her vocabulary.

Thanks for your encouragement and support. With your help and support, we'll have a great victory on November 3rd. Best wishes —

Hillary

Diana, Princess of Wales (1961–97)

The openness of the writing indicates her desires for the social and sensual world around her. Pride is important to her, too.

The movement to the left indicates her being less at ease in facing problems. The emphasis on the middle zone at the expense of the upper zone reveals a greater interest in people and things than in ideas.

With endless gratitude & thanks — Diana

Using Graphology

Graphology is possibly one of the most underrated secret weapons a company leader, social worker, psychiatrist or careers assessor, among many others, can have. Revealed in a few short lines of handwriting are all the personality strengths and weaknesses you could ever want to discover about the person you are evaluating.

The practical uses of graphology

Graphology is now widely used by a number of professionals; these include:

- **Employers and recruitment professionals** To assess potential candidates.
- **The law courts** To detect fraud.
- **Schools and social workers** To assess a child's ability and also whether they may have been ill-treated or are disturbed in any way.
- **Careers assessors** To put school leavers and those who require vocational guidance on the right job trail.
- **Couples** To indicate whether they are compatible.
- **Psychiatrists** To investigate personality problems.
- **The medical profession** As an early means to detect the onset of certain conditions.

The following chapters explain how graphology can be used to identify or validate personality traits and characteristics, together with some case studies.

Children

The development of a child's handwriting takes place gradually at first, but once they begin school the process starts to accelerate as students are encouraged to practice their writing for many hours a day. Once the letters start to join together and writing has become fluent a child's personality can begin to come through.

How handwriting develops

The act of scribbling represents children's first attempts at written expression. Scribbling usually begins at about two years old and continues until the child makes an effort, at approximately three or four years old, at drawing familiar objects.

At this early stage, the child's marks will reveal only general indications of character. Later, when letters become familiar and the personality is more developed, personality traits become clearer. By the age of five, children usually give up scribbling entirely in favour of drawing. By this age letters are generally large and irregular, due to the unfamiliarity of their shapes and the as yet undeveloped coordination.

My school is very nice because I liked my hed techer and also because I liked my teleshon techer.

Hetty, aged 5

At the age of six, the average child is able to print their own name. This is, in fact, one of the indications that a child is making healthy progress. First and last names are often written on different lines or are separated by large spaces.

It is at about seven to eight years old that one's writing abilities start to mature. At this age the child should be ready to use cursive writing, at which point an analyst can begin to pinpoint the high-flyers of the future.

Dickens went to Rome Lane School and then Claer Lane School until 1821. At school he was very fond of reading. His education was cut short because his father was imprisoned for debt. Two days after the celebration of his twelfth birthday, Dickens found himself at Warren's blacking factory.

— Isaac, aged 9

The writing of three children, Hetty, Isaac, and Theo – from the same family and taught in the same school – shows the evolution of writing skills from five through to 12. Middle child Isaac is left-handed.

A fantastical tale of sorcery and betrayal from a boy hidden for nearly six hundred years. Sebastian is the alchemist's son, pursuing his father's enemy through the centuries.

Theo, aged 12

Identifying gifted children

The style of a child's handwriting at a relatively young age can be an indication of academic potential, as we can see from this case study.

Case study

A father of an eight-year-old child asked me to comment on his daughter's writing. Having examined the writing, I was of the opinion that the father was playing a trick on me and that the writing had been executed by the girl's mother. Characteristics that appeared were usually to be found in an individual of more advanced years.

To satisfy my curiosity, I asked the father if I could meet his daughter. When I asked her how old she was, she said she was eight and a half. I asked her if she had any idea what she would like to do when she was grown-up and she said, 'I would like to be an MP and particularly a cabinet minister.'

I would enjoy going to Ireland for my holidays, where there is a remarkable zoo.

It was evident that she was already well on the road. She was mature and clear-thinking. This is an excellent example of where handwriting can identify the ability and potential of children.

Handwriting of children and teenagers

Up to and including the 19th century, there was some truth in the statement that handwriting simply reflected the age in which one lived. But in the last 100 years, education has expanded, rigidity has lessened, and people are able to express their individual personality in their handwriting.

My lecture circuit includes visits to many schools. Handwriting varies tremendously within the UK educational system. At an internationally renowned (and very expensive) school for girls, one finds a high standard of writing that shows, in the main, determination and stubbornness. The students speak with authority and most know what career they are aiming for. They can and will succeed. What is interesting is that their writing indicates that their success will only be in something that meets with their prior approval.

Observation of the writings in UK state schools (and I, of course, generalise) tends to reflect indecision and short-term objectives. At one school I asked four male students what they would like to do in life. Three immediately replied, 'Play football for England,' while the fourth had no idea at all.

The third category of school I visit is the faith school. In one school in the south of England, the writings were well presented, organised and show determination. Strict discipline was maintained within the confines of the school (and no doubt within the family home). In a particular girls' school I visited, religious observance was of prime importance, and none of the pupils were allowed to watch TV, for fear that it might corrupt their minds. The majority of the girls had small, introverted, logical writing, indicative of the environment in which they lived.

The Family

What determines how we write? Where we learned
– the type of school, the country we live in? Who
taught us? We have established that personality
plays a large part, but how much of this is genetic?
In this chapter I put this to the test.

Family case studies

In these two examples I will compare samples from members of the same family and see what conclusions we can draw.

Case study 1 Three generations

Is writing 'learned' or does it come from the brain? The handwritings of three generations of the same family were analysed to determine, among other things, whether or not handwriting reveals inherited characteristics. To what degree, if any, is handwriting affected by genetic inheritance as opposed to family upbringing?

The three generations consisted of:

- Two sets of grandparents
- The father
- The mother
- A 14-year-old daughter
- A 12-year-old son
- Male and female twins aged ten

The grandparents

The analysis of the grandfathers' handwritings simply revealed their generation. They showed a principled uprightness of character and they were disciplined and practical individuals who took care before making a decision and didn't get sidetracked. They may, on occasion, have failed to see matters from another person's perspective.

When I consider how my life is spent. ere half my days in this dark world and wide, lets get on to the last line. They also serve who only stand and wait. How about wally. The quality of mercy is

There are people who are naturally inclined towards study, prayer and an overall appreciation for matters spiritual. The rest of us, we believe, are incapable of living on such a lofty plateau. Yet we fail to recognise that very few people are born with an inherent appreciation for fine literature, art or classical

The grandmothers' writings, again, revealed the age in which they grew up. While demonstrating determination and discipline, enthusiasm for living remained under a strict umbrella of self-control and high principles. This generation's strength lay in their conscientious concern to do things properly, in time-honoured fashion, and not by using improved innovations.

In the centre of the room, clamped to an upright easel, stood the full-length portrait of a young man of extraordinary personal beauty, in front of it, some little distance away, was sitting the artist. As the painter looked at the gracious and comely form he had so skilfully mirrored in his art, a smile of pleasure passed across his face, and seemed to

The mother
A lady who likes to keep her feet on the ground, like her own mother she possesses the ability to control her desires, tendencies and sentiments. This does not mean that she does not have strong feelings and emotions. It means that she has control over them rather than they over her. The writing reflects the fact that while both grandmother and mother share similar characteristics, the latter demonstrates more flexibility, probably reflecting the age in which she lives. However, it should be kept in mind that this lady is predominately an introvert by nature and therefore is not necessarily displaying typical 21st-century characteristics.

Confound him, he wearied me with arguments to show that in anything like a fair market he would have fetched twenty-five dollars, sure - a thing which was plainly nonsense, and full of the baldest conceit I wasn't worth it myself. But it was tender ground for me to argue on. In fact I had to simply shirk argument and do the diplomatic instead. I had to

The father

It's a world of surprises. The king ponded: this
was natural. What would he brood about,
should you say? Why, about the
prodigious nature of his fall, of course - from
the loftiest place in the world to the obscurest;
from the proudest vocation among men to
the basest. No, I take my oath that the
thing that galled him most, to start with,
was not this, but the price he had fetched!
He couldn't seem to get over that seven dollars.

The father is a particularly interesting individual. While he
has inherited clear thinking, clarity of mind and a quiet and
moderate manner from his own father, his intuitive mind has
obviously been inherited from his mother.

The children

The eldest child is a 14-year-old girl who can surely be said to be a 'chip off the old block'. The writing indicates an intelligent, well-mannered, determined young woman. Substantial similarities exist in the character of this child and her paternal grandmother.

Well it stunned me so, when I first found it out, that I couldn't believe it; it didn't seem natural. But as soon as my mental sight cleared and I got a right focus on it, I saw I was mistaken: it was natural. For this reason: a King is a mere artificiality, and so a King's feelings, like the impulses of an automatic doll, are mere artificialities; but as a man, he is a

The second child, a 12-year-old boy, is another 'chip off the old block'. The writing indicates that the young man is single-minded in his approach to matters in all spheres of life. There appears to be a lack of adaptability, which means that he will not respond to quick changes of pace. In later life, he may be somewhat difficult to work with – a mirror image of his paternal grandfather.

Dear Mr Conway,

Thank you for the Calculator,

from
Alistair

Then we come to the ten-year old twins, who are not only different sexes, but possess different characters, which is more than evident in their handwriting. They are of the age when their writing abilities have generally reached maturity.

The girl's writing indicates that she tends to be cool and collected. There are already indications that her character is being formed in line with her mother and her maternal grandmother. An individual who conducts herself with dignity and inner strength, in later life she would be expected to be capable of achieving anything that meets with her prior approval.

> so a King's feelings, like the impulses of an automatic doll, are mere artificialities; but as a man, he is a reality, and his feelings, as a man, are real, not phantoms. It shames the average man to be valued below his own estimate of his worth; and the King certainly wasn't anything more than an average man, if he was up that high.

The boy (handwriting not shown) likes to display a tough image to the world. His writing displays impatience. He is still at the age when he believes creating a scene will achieve his desires. Nonetheless he possesses intelligence, and there are already indications that he will succeed and prosper in his chosen occupation.

I am grateful to the parents of the four children who agreed to meet me. Having read the analyses they felt that the majority of the comments about their family was correct but, like many other people, failed to see some of the characteristics in themselves.

Very few individuals know themselves. Often when discussing an analysis with an individual, they will vehemently dispute certain conclusions. However, their close relatives are often able to point out the validity of such comments.

But some people do know themselves. One is sometimes able to cure a fault, provided one knows it exists. That is why a handwriting analysis not only describes your personality, but can often point out what is holding you back and why. Armed with this information, many people can move forward with confidence.

Conclusions

Perhaps in the family above, the parents taught the children to write, which might explain some similar characteristics in their handwriting, which a graphologist then identifies as similar characteristics in their personalities.

Or do the children have similar characteristics in their writing because they happen to have shared personality traits with their parents?

Case study 2 My own family

The following example of my own family indicates a household where the parents did teach the children to write, but where the children's own personalities are revealed by their handwriting.

I have three adult children, all brought up in the same environment and each with a unique handwriting that describes them accurately.

Firstly, it is interesting to observe the writings of my daughter Debra and her mother Marion. Their writings not only reflect the different personalities, but to some extent the different generations – although Marion taught Debra to write.

Marion's writing is precise, organised, disciplined, and reflects her generation. In the present day, she could hold down a job with responsibility and trust. She knows well the difference between right and wrong.

As Autumn sets in, leaves fall
off the trees, + the days get
shorter, indicating that Winter
is on its' way.

Marion Conway

Debra's large, elaborate writing , on the other hand, demonstrates determination, forcefulness and a desire to move forward in a straight line. Her degree is in Management Studies and she holds a high-powered position in marketing.

A balanced diet is one that perfectly suits your growing child's needs. Breast milk or formula is an essential source of nourishment throughout the first year of your baby's life, but from the time you begin weaning him, you should work towards establishing a diet that provides the five essential nutrients: carbohydrates, vitamins, fat, minerals + protein.

My elder son, Jeremy, has a first-class Chemistry degree, a master's degree and a PhD. His handwriting is small, logical, precise and cuneiform. It accurately reflects his brilliant and methodical mind, which is well suited to research.

Alkali hydroxide gives a white ppte soluble in excess. The white precipitate, $Zn(OH)_2$ gives the oxide when dehydrated the white \rightleftharpoons yellow reversible colour change observed on heating the oxide is a useful confirmatory test.

Addition of sulphide ion to a solution of a

Edward, my younger son, displays a threaded, sensitive type of writing. His degree and work are in finance but his writing shows a free spirit who lives life to the full.

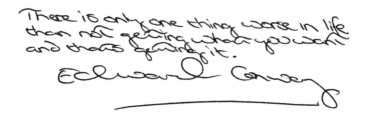

There is only one thing worse in life than not getting what you want and that's getting it.

Edward Conway

And finally to my own handwriting, which bears no resemblance at all to that of my three children, and whose characters bear no resemblance at all to mine!

I was born a massive introvert, who forced himself to become an extrovert and has 90 per cent succeeded. An introvert will very rarely speak in public. I forced myself to such an extent that I am now uncomfortable being in the audience and need to be the speaker.

Contrary to this, I still have difficulty in responding to an uncomfortable situation. So some of the introversion still exists, causing some conflict in my writing style.

Never forget that the most important thing in life is to
"Acquire an occupation you enjoy & You will never have to work a day

How changes in circumstances are revealed in handwriting

Writing tends to change to some degree as one progresses through life. Those who suffer a major traumatic experience, either in a good way or a bad way, will immediately see their writing change. Some writing will eventually revert back, but others will remain changed forever.

A good example is where a couple have been happily married for, say, over 50 years and then one of them dies: the shock will immediately change the writing of the survivor. More often than not the writing will remain changed, as the individual may never fully come to terms with the new situation in which they find themselves.

An interesting experiment took place in New York in the late 1950s. Social and psychological workers took 20 teenagers out of their deprived environment in the Bronx for 12 months and placed them with middle-class families in suburbia. These teenagers were not chosen at random. They had all experienced disturbed lives (half had undergone corrective training) and a graphologist had also ensured that the handwritings of the teenagers reflected this.

The results were quite astounding. More than half turned over a new leaf and became model students. Most of the remainder became 'adjusted' individuals. Only two showed little change, and it was subsequently established that these two, after the event, continued their lives as though nothing had happened.

So what did the handwriting reveal, if anything? The graphologist picked out from the handwriting, with little effort, those who had completely changed. In those who had adjusted, while the handwriting had improved, signs of aggression and irritation still appeared, albeit to a much lesser degree.

The writings of the two who had rejected the experiment remained the same. In fact, one of the participants' handwriting demonstrated even more aggression and disturbance than before, indicating that the experiment had, in this case, been unsuccessful.

Another side of this is where an individual has lived a quiet, well-organised, disciplined life and suddenly finds they have come into a large amount of money, such as a lottery win. This can affect individuals in different ways.

There was the case of a man who in the late 1990s won several million pounds and went crazy, buying everything he could lay his hands on. Interestingly enough, because he was an impulsive individual before winning the money, his writing reflected little change. The only difference worth noting was that after the event the signature showed distinct arrogance.

Around the same time an older man won even more money. He was an organised, precise individual and his writing reflected this. The win was like a thunderbolt out of the sky. His writing became ragged, letters incomplete, sentences unfinished. The win was the last thing he needed.

Finally, there was the gentleman who won a substantial sum but continued to live his life as though nothing had happened. His handwriting, as expected, remained the same. As far as he was concerned, the win had no importance and his writing reflected this.

Love and Marriage

Historically people were not always permitted to choose their own partners: matches were made for dynastic reasons or for the advancement of the family. Now most of us do have a choice, but how carefully do we make it, and what could graphology tell us about our prospective partners?

Evaluating a marriage

It is not necessary to be a psychologist, or even a marriage
counsellor, to know that a high percentage of marriages now
fail because they were doomed from the outset. Graphology
can be used most effectively to warn people of potential
difficulties ahead, so that the decision to marry can be a
well-considered one.

Compatibility

When evaluating a marriage it is necessary to ask a number of
important questions.

- Has marriage outlived its usefulness?
- Are people no longer able to live together in peace and
 harmony?
- Has society moved too far?
- Are there too many outside attractions?
- Do couples fall into marriage without giving it sufficient
 consideration?

Forming a lasting relationship

If a relationship is to last, it is relevant to pay some attention to the question of suitability, to forewarn individuals whose marriage will certainly (or almost certainly) fail. Graphology is capable of providing prospective partners with a character portrait of each other. This will enable them to check their own impressions and expectations on the basis of an unbiased analysis.

The most essential element for the successful survival of a relationship is harmony of objectives. This becomes increasingly evident once the first flush of love and romance has given way to the practical realities of running a home, raising a family and sustaining a relationship. The key to the question of compatibility lies not only in the form of attraction between a couple, but in the potential for two people to develop a sense of companionship and be able to tolerate one another in the longer term, in a spirit of shared values and aims.

A handwriting analysis compares the writing of the two individuals to see how well they are likely to get on together in the longer term. It particularly identifies how they communicate

their feelings in relationships. It highlights both partners' constraint and rapport, their energy levels and anxieties. The more personality traits that are uncovered, the more material there is with which to compare the two writers and estimate where problems are, or are more likely to appear, in their relationship.

Graphology is unique in its ability to ascertain such factors objectively. It can therefore help to establish whether the proposed match is likely to endure. Good graphologists are able to perceive the character structure of their subjects. But in assessing the likely prognosis for a prospective marriage, they need to have a viable model on which to base their criteria of potential success or failure.

The table on the following pages shows some of the characteristics that graphology can identify and may help you to establish or confirm the compatibility of your own relationship, by comparing your own handwriting with that of your partner.

How compatible are you?

Character of writing	Significance
General type or look of the writing	Personality type
a) Size b) Width c) Spacing (between letters and words)	Standard comfort and style of life
Slant (direction) of writing	Social type: extrovert, introvert, independence
Size and character of upper and lower extensions	Intellectual, materialistic, sexual inclinations
Forms of connection	Ways of coping with problems, adapting to life

How suited are you?

16–20 You are living in heaven … you are to be envied.
12–16 You are happily married … congratulations.

Compatibility	Points
Should have some similarity	4 Very similar 3 Similar 2 Slight similarity 1 Totally different
Would expect two out of three to be similar	4 All three similar 3 Two similar 2 One similar 1 Slight resemblance to any one
Small difference can assist	4 Identical slant 3 Slight variation 2 Difference in degree substantial but in same direction 1 One right. One left.
Exaggerations in opposite zones – individuals live in different worlds	4 Similar in all zones 3 Slight differences 2 One zone very different 1 One exaggerated upper zone and no lower zone or one exaggerated lower zone and no upper zone
Similarities are important	4 Connections very similar 3 Slight differences 2 Very different 1 No similarities at all

8–12 You are surviving ... but things could be better.
Under 8 Are you still married?

Graphology
at Work

One of the main uses for graphology is in the
selection of employees. Handwriting analysis
in recruitment offers a precise alternative to
psychological tests, because it is independent of
ideas and intellectual content.

Staff recruitment

How accurate and meaningful are CVs and references? Is the previous employer delighted to get rid of someone? A clever interviewee can fool you. Poor or nervous interviewees can underestimate themselves and you miss out on capable and suitable staff. But the handwriting will never hide the truth. For instance, it can reveal:

- **Physical and material drives** An individual's energy and vitality.
- **Emotional characteristics** Feelings; moodiness; whether emotions trigger dangerous reactions.
- **Intellectual style** Thinking style; methods employed in problem-solving; paying attention to detail.
- **Personality traits** Confidence or lack of it; self-esteem; adaptability.
- **Social behaviour** Ability to handle colleagues/clients/ associates; sensitivity.
- **Vocational implications** Ability to tackle a project; job efficiency; performance; organisation.

Some major companies or recruitment agencies ask for a handwritten application letter. As well as showing whether the individual can write and spell, this detects aspects of the applicant's character that would never be revealed at interview.

It is usual to pull out the most promising candidates for a job from these applications, and many companies employ a graphologist to do this for them. But what kind of employee are you seeking? Does it not depend on the job you are offering?

Do you need someone who is totally focused on their work, who concentrates on a computer screen and figures all day, who should not be disturbed and will not disturb anyone? Or does your vacancy suit a lateral thinker, with an expansive mind, who involves everyone in what they are doing? Does the job need someone who is open and honest, or someone who knows how to be tactful and discreet? Are you looking for a team leader or a follower, a worker or a queen bee?

Earlier chapters have concentrated on specific aspects of handwriting analysis, but none of them should be used in isolation as a means of identifying a person's true character. A professional graphologist will be able to help you find the right person, by analysing various aspects of their handwriting and taking them all into account. Here are some of the indications they will be looking at:

I need someone who is physically and mentally suited to the job

Look at the pressure of the writing. Heavy pressure implies the writer is physically fit and energetic, usually strong-willed and confident. Very light pressure could indicate someone who is very timid, with low energy levels, or poor health. But too-heavy pressure can show lack of sensibility and finesse, opportunism, laziness, and even brutality. If the writing gets progressively heavier it may show hypertension or circulatory trouble.

Look at the baseline of the letter. A straight line shows an emotionally stable person, but they could be a little dull and staid. An upward slant denotes ambition and enthusiasm. But a downward sloper could be physically unfit, emotionally volatile or pessimistic.

I need someone with intellectual capacity and vocational ability for this job

Find where the candidate has written the capital letter 'I'. A single downward stroke shows the person is intelligent, straightforward and genuine. A cross bar 'I' added top and bottom indicates someone who has a high self-opinion. A capital letter written as a lower-case letter shows a very immature ego, while one with a loop at the top could represent repression, inhibition and avoidance of responsibility. Next, study the loops on the bottom of letters like 'g' and 'y'. Medium-sized loops indicate a writer who is self-assured and realistic. Very large loops indicate a very imaginative and egotistical character.

I need to know whether this candidate is a leader or a follower; an introvert or an extrovert

Look at the colour of the ink they have chosen. Blue indicates they are calm, dependent, and with no desire to be exceptional. Black is the sign of a leader; someone who wants to make an impression and is decisive.

Then look at the slant of the writing. In a right-handed person, a backward slant is usually a sign of an introvert, while a forward slant denotes an extrovert. But this is disregarded for left-handers.

Leadership potential

A leadership vacancy can cause resentment and disruption, especially if an unsuitable candidate is appointed. When a promotion is under consideration, it can be difficult to decide between candidates. It is likely that they have all been with the company for some time, they are equally qualified for the post and you have no doubts as to their integrity. Here is what a graphologist will be looking at:

- In general, the people who have the self-confidence to take on a leadership role have bolder, bigger handwriting. But some of them may have a tendency to be all show and no ability. If a more human approach is required you may need someone with a lighter hand.
- Look at the shape of the letters, especially the 'M's and 'N's and the way they are spaced on the page. The people with pointed letters are persistent, decisive and have intellect. However, some of them can be aggressive and inflexible. People with well-formed, rounded letters are softer in character but are also good communicators.

So decide which type of leader you need; evenly spaced words show good judgment and emotional stability.

- Notice the margins

People who begin well into the page from the left are often intelligent and independent. Avoid those who leave a wide right-hand margin. They can be afraid to embrace new ideas and dislike contact with other people. They may fear the future.

- Study the 'T's in the text. These can give a big clue to
 leadership potential.

If the top bar of the upper-case 'T' is slanted upward from left
to right [/], this person is ambitious. The other way round [\]
shows lack of ambition or failure to achieve an ambition.

 If the cross bar extends over the whole word, they may be
overprotective of their team and even patronising. Someone
with a conventional, precise bar to the T would make a more
suitable candidate.

 The lower-case 't' is even more revealing. If the cross bar is
missing, this person is careless or absent-minded; certainly not
the person to promote. A low cross bar shows an inferiority
complex. But those with a high cross on top of the stem may
well have excellent leadership qualities. And those who cross the
't' through the middle of the stem are conscientious and take
responsibility well. So these are the two to look out for.

- The letter 'F' is often considered by graphologists to be very
 revealing, as it is the only letter to pass through all three
 zones. In a capital 'F', a positive sign is a rising top bar as this
 indicates a desire for self-improvement. Somebody with a
 full upper loop on their lower case 'f' will be articulate and
 open-minded.
- The letter 'y' shows an individual's attitude towards material
 success and pleasures. A long lower stroke with no return
 loop that is applied with light pressure indicates someone
 with a money-minded attitude. These people suit jobs in
 banking, insurance and accounting but not those where
 creative flair takes precedence over finance.

The 'write' person for the right job

When employees are not working well, it is not always their fault. The company may have promoted or pushed them into a job that does not suit their personality. It is a matter of character and aptitude, as much as ability. Some are leaders, others prefer to follow. Some employees are good organisers but not good at physical work. Others work well with their hands, but are impatient when confined to a desk. A good graphologist can tell you if you have the right (or wrong) person for a specific job simply by looking at their handwriting. Here are some sample indications:

- You can tell something is wrong when the individual's writing takes on a marked downward slope. This indicates that they are not happy with life. They may be becoming disillusioned or depressed, and getting overtired or heading for illness. Check that there is not a problem at home before changing their work routines.

- Uneven spacing between the lines shows that the person is easily irritated or volatile. They may panic in an emergency and lose their temper if someone is rude to them. Move this person away from your customer services desk!

- Consider the size of the writing. Large letters denote outgoing, lively people who will not sit happily in the back room taking stock or adding figures, but they could shine elsewhere. Small, precise writing belongs to someone who prefers detailed work and may lack confidence to face crowds of people in the front line. However, extremes can mean the opposite – an extra-large signature can denote overcompensation for an inferiority complex.

- Look at the shape of the letters. Pointed, gothic-looking 'M's and 'N's show someone who is a self-starter and is attentive to detail. But do not try to boss them around. They will fight you with bitter determination. Just let them get on with things. Similarly, don't expect those with incomplete 'M's and 'N's to be sharp and precise … especially if their upper-case letters trail off or join into the next letter. They may be too easy-going to care about minor details. Or they are too overworked to have the time to form their letters properly. Either way, do not expect them to be accurate.
- Notice the spaces between letters and words. Reasonably spaced, even writing shows a good organiser and problem solver with strong management skills. Cramped writing indicates talkative people seeking companionship. They are nice to know, but do not furnish them with company secrets. Widely spaced writing shows self-confidence but can be a sign of impatience, so judge them carefully.

These are only some of the indicators. Height and width of letters, the way they are or are not joined, how (or if) the 't' is crossed and the 'i' dotted in both upper and lower case, shapes of other letters, and margins are all written evidence of the personality of the individual.

How to create the perfect team

Individual unhappiness in teams creates ineffectuality. By the time you notice something is wrong, it may be too late to change the team structure. To make sure you place the right people together from the start, get a sample of their handwriting. Here are some of the indications you should be looking for:

- Look at the general overall effect. The more similar the pattern of writing, the more alike and more compatible the personalities.
- Study the height and width of the letters and the spacing between words. Those whose style is cramped and close tend to speak in the same way. They have fixed views and fiercely adhere to their opinions. They work well with the introvert who has to concentrate on figures or precise details all day. Those with evenly spaced writing are happy to talk with all and sundry, but they know when to talk and when to work. They are also good problem solvers.
- Look at the slope of the writing, which indicates whether the writer is introvert or extrovert. A good mixture of slopes will give you a balanced team, but avoid very exaggerated forward or backward sloping. Too far forward can indicate pushy people, trying to impose their opinions on others. Heavily backward slopers are highly individual; they are loners rather than team players.

BUT, none of this is true if the writer is left-handed. It is not simply that the opposite is true. It is far more complex and requires the considered view of an expert.

- Notice the way the writers join their letters. People who join all their letters tend to think before they act and coordinate their ideas well. Those who don't join letters very often act first and think later. In a team, the two types could irritate each other immensely.

For a really good team look for people who join small groups of letters within whole words. These are the adaptable people. They know how to combine logic with intuition, to cope with the present, and still look for new ideas.

Health

Many graphologists believe that handwriting is a barometer of health. The patterns of emotional response, conscious behaviour and cognitive functioning, as determined by the brain, find expression in the handwriting and can be analysed and understood. Marked changes can be seen in the handwriting of people who become ill, very tired, troubled or stressed. And remarkable similarities occur in the writing of different individuals sharing medical or mental conditions.

Writing and health

When writers' thoughts dwell on any part of the body, that concern is shown by the stress or emphasis in the corresponding area of the handwriting. The human body is represented in handwriting via the concept of the three zones: the top of the upper zone relates to the head, with the neck and shoulders just below; the upper spine, chest and abdomen are in the middle zone; the genitals, legs and feet form the lower zone.

Brain function has a crossover effect, so that injury to one side of the brain results in damage to the opposite side of the body. Similarly, a problem on the right side of the handwriting refers to the left side of the body, as viewed from the front.

Illness is shown in the handwriting by certain changes in the script corresponding to the area of the body affected. These indications appear because (either unconsciously or consciously) writers want to indicate that there is a problem and to highlight where the problem lies. Some indications are as follows:

- Difficulty in making curves, with the resulting flattening of sides, top or bottom.
- Pointed loops of ovals.
- Uneven pressure or avoidance of pressure.
- Hesitation marks (dots).
- Interruption and gaps in letters.
- Changes of direction (indentations).
- Heavier blots appearing randomly, not due to a faulty pen.
- A sharp downward baseline.

Case study 1

A small group of individuals who had experienced the trauma of cancer allowed me to examine samples of their handwriting at three stages: the pre-cancer period, during the illness itself, and when fully recovered or in remission. Although the group was small, some striking similarities were apparent.

The most significant similarity was a feature of stroke formation called segmentation, which was apparent in the majority of writings prior to and during the period of the cancer. Segmentation is caused by tiny tremors of the muscles used in writing, transposed into 'up and down' movements on the paper. This clearly distinguishes it from the signs of gross tremors, present in the writing of some elderly people, which produce a side-to-side shake and is usually a subtle early-warning sign of health dangers ahead.

Another common factor prior to the diagnosis of cancer was an apparent inability to corner letters correctly, resulting in a sudden upshot. The smooth transition from a downward to an upward stroke movement was missing. This departure from normal handwriting is caused by the writer's inability to exert the fine muscle control required to corner smoothly and gradually. Instead of gliding around the bend in forming the letter, the pen point appears to have been jerked upward, resulting in the sharp strike, which on the downward stroke appears to lose energy, resulting in a decrease in pressure. After recovering from the cancer, the writing returned to its normal curved formation.

A further shared characteristic, as the cancer took hold, was that the lower-case letters became incomplete and broken. Physical weakness had caused the writing muscles to cease functioning momentarily before the letter could be completed. Instead of being able to produce a continuous movement, the writer had to tack on another stroke to finish off the letter.

Ink trails are apparent at a number of points in the scripts. The trails are the result of a brief loss of strength where the writer felt insufficiently strong to lift the pen point from the page, instead letting it drop back to the paper momentarily.

As the cancer took hold, the baseline of the letters in the sample handwritings became less stable and wavier. However, after having recovered, the patients' baselines, without exception, returned to normal.

It is extraordinary to contemplate how subtle and sensitive are the responses of the mind and body where brooding health troubles are concerned, manifesting themselves in minuscule aberrant movements of the hand in the process of writing. The significance is that handwriting provides a scaled-down version of an individual's response to the demands of life. A weakness in the script is the first indication of a physical weakness. Unless this can be diagnosed and treated it will, in all probability, eventually be marked enough to appear in more obvious ways.

It is important to distinguish between short-term weakness, producing temporary changes in handwriting, and the more permanent indications, which warn of lasting health problems. Although handwriting can reveal early-warning signs, it does not provide a diagnosis and a doctor should always be consulted.

Case study 2

Progressing from my initial investigation of the writing of a group of cancer sufferers, I examined whether a larger group of individuals who shared a traumatic experience would show evidence of their ordeal in their subsequent handwriting. I took a group of six men and six women who were all survivors of the Nazi concentration camps of the 1940s. They were all of a similar nature: people whose energy and determination had carried them through personal distress and anxiety and who, for the most part, were capable of pushing themselves to meet the challenges that confronted them. They were, moreover, possessors of the survivor instinct.

Their writings indicated that in their youth they were capable of sustained hours of work, giving a project 100 per cent of their efforts and attention. The majority of the sample handwritings indicated that the writers were less at ease when facing problems outside their own close circle of friends or family. Their attachments ran deep and they would be courageous and tenacious in defending them.

They all enjoyed the company of others, but felt a great need to withdraw periodically and have time to themselves, perhaps because of their experience in the Holocaust. They also tended to be quite conventional and felt inhibited about breaking free of established patterns of thought.

One might conclude that this group had to have these shared characteristics and natures in order to survive. However, there is also evidence that their traumatic experiences changed their handwriting and that the altered script became their norm. When people have experienced a fundamental change in their lives, they will feel they have no alternative but to accept the new situation. This adaptation will become part of their personality as well as their handwriting.

Deception and Crime

Insincerity or dishonesty in handwriting should be examined in the context of a collection of signs and not in isolation, as there is no conclusive single sign. Some apparent signs of dishonesty may be innocent, but they could become indicative of dishonesty, insincerity or even criminality if present in certain combinations and under certain conditions.

Dishonesty

Insincerity or dishonesty in handwriting should be examined in the context of a collection of signs and not in isolation, as there is no conclusive single sign. Some apparent signs of dishonesty may be innocent, but they could become indicative of dishonesty, insincerity or even criminality if present in certain combinations and under certain conditions.

One might argue that the intention to deceive others lies at the heart of all forms of dishonesty. Psychologists tend to classify deceit as an escape mechanism. But deception can be used for altruistic and humane reasons. The 'little white lie' can be a way of tempering the truth to protect egos, cushion sensitivities and preserve relationships. Situations occur when discretion may prevail over the urge to be brutally honest.

There are numerous reasons why some individuals find it necessary to deceive themselves or others. Misrepresentation or distortion of the truth can be a means of hurting or inconveniencing others, or of protecting them. Alternatively, deceptiveness can be born of evil intent; the desire to wilfully defraud and harm others.

Graphological tests are not always conclusive. The writer may have a reasonable excuse for their method of writing. They may simply be poor at spelling, or a lazy writer, so DON'T DEPEND ON THESE TESTS ALONE. A single instance of any of these transgressions is not a sign of guilt. Whatever your suspicions, don't tackle the person without proper evidence and if in doubt, seek expert advice.

What to look for

Look for six or more characteristics in a sample of handwriting before you start to worry or accuse. But if you already have suspicions, this may be the factor that prompts you to further investigation.

1. Ask the person concerned to write something for you. Watch them writing – often people who feel guilty write slowly, weighing up what they should or should not say. There is an important connection between dishonesty and slow writing. The key factor is that the slow writer who tends towards deliberateness is inclined to be calculating. Fast writing may indicate more sincerity than slow writing, but the latter, in isolation, does not necessarily indicate insincerity.

2. Note if there is a lack of stability in the writing – changes in style or slant. This can manifest itself if the person's signature is wholly different from their handwriting.

3. Do some words look as though the writer has gone back over and retouched them? This is especially relevant if you have a signature, which may be forged (maybe on a cheque, purchase order or medical form).

4. Is there omission of letters or parts of letters? Often a guilty person will be concentrating so hard on the whole, that they don't notice they have left letters out. Or they may neglect to join the loops of letters like 'O' and 'D' or lower-case 'a'.

I would enjoy going to Ireland for my holidays, there there is a remarkable zoo.

5) Lower case 'b', 'd', 'g' and 'q' may look as though they've been written in two parts, with a rift through the middle.

My name is Kim and I have travelled a fair distance today. Taxis are a nightmare and costly.

6) Watch out for handwriting that appears artificial or characterless. The writer could be hiding something, especially if they think you are studying their handwriting!

We would like to thank you for the lovely gift which you kindly gave

7) If upper-case letters are disproportionate in size to the rest of the script, the writer may be subconsciously hiding behind them.

8) Extra dots after words or at the end of the script could indicate guilt.

9) Study the baseline of the writing. If it's wavy and erratic, you have cause to be suspicious, although this could indicate that the writer is ill, or simply moody.

I would enjoy going to Ireland for my holiday when there is a wonderful zoo

(10) Anyone who is right-handed but slopes their writing severely to the left may have emotional problems. The same goes for a left-hander whose writing slopes to the right.

(11) Look at the personal pronoun 'I'. If the letter itself is written as lower case or very small, the person could subconsciously be making themselves insignificant, so you won't find them out.

I would enjoy going to Ireland for my holidays, where there is a remarkable zoo.

(12) Is the pressure of the writing even or does it vary? Perhaps some letters have strong downward strokes, but fading loops. This could be a sign of distraction or guilt.

(13) Watch how the person behaves when they are writing. Do they appear confident? Or are they uneasy – possibly hiding their writing with their arm or a stack of books or papers?

(14) Missing letter parts – these often involve threads appearing inside words themselves. They indicate elusiveness and insincerity. Vagueness and imprecision in the writer's statements will conceal their true thoughts and feelings and is often a strong sign of insincerity, lying or deceit. Such writers will avoid accountability and responsibility,

employing vague obfuscations which appear conciliatory, but on reflection are a way of brushing you off. Missing letter parts equate to the writer leaving out essential information, which is another means of concealment.

which was the original contract
The deliver was left
outside the house without
first checking to see if the
owner was there to sign off

Examples of 'dishonest' handwriting

The following samples of handwriting illustrate dishonest tendencies. The presence of one of these signs does not mean that the writer is dishonest. One needs to see at least five or six features appearing in the same handwriting to accept it as an indication of the person's untrustworthiness.

Rhythmic disturbances

'Rhythm' is the general appearance of the writing with regard to evenness, tidiness and being pleasant to the eye. Notice how in this sample the line of writing undulates. Extensive research into the handwritings of criminals shows that hardly any possess good rhythm.

Illegibility, caused by indistinct forms

This can take many guises, but attention is drawn to illegibility when it is the result of thread forms which are unfinished or indistinct. This generally indicates secrecy. The writer may keep their hand covered all the time and will not make the reasons for their actions clear. They feel it is advantageous to remain enigmatic and do not like to reveal their motives and intentions.

People who write illegibly often do not want you to see them as they are. They will often give vague and contradictory accounts of themselves in order to confuse, and commit themselves as little as possible. Illegibility can also indicate little care or even indifference for anyone else. By contrast, average or good legibility indicates that the writer is content for you to see them as they are.

The slow creeping arcade

An 'arcade' is like an arch in architecture. It is most obvious in the letters 'm' and 'n', but can also apply in an inverted form to 'u', 'v', or 'w'. The letters will be markedly rounded and arch-like in appearance. The term can also apply to the c onnecting strokes between letters, which would be noticeably rounded.

 Oddly, this feature is often overlooked or underrated in its importance. However, a stretched and widened arched arcade, usually in connection with a very small middle zone, indicates extensive deviousness and usually suggests a person given to lying and gross dishonesty.

we cold put on a Seminar which mixes
my financial services with your speciality

Left-slanted or left-arcaded writing

In a right-handed person, this is the classic indication of the less intelligent cheat, especially when present with 'covering strokes' (i.e. strokes that go over the letter more than once) and slow speed, making the script look as though it has been written very meticulously and with effort.

It is very common in small-time crooks, indicating a person who would be very unreliable in their statements. It presents a manifestation of deceitfulness that lacks the real danger of being underpinned by a sharp mind.

I would enjoy going to Ireland for my holidays, there there is a remarkable zoo.

Enrolments

An enrolment is a stroke that curls in on itself, such as a spiral in the final stroke of a letter. In this example the flourishes in the handwriting generally depict a sense of vanity. This often manifests itself in a tendency towards complete selfishness and greed and a low estimation of other people. It can accompany a tendency to blur and massage facts to suit the purposes of the writer.

Covering strokes

The key feature here is the tendency to go over the same letter more than once. This needs to be present to some substantial degree in the writing before a definite conclusion can be reached, but in excess is symptomatic of a person who plans their subterfuges in advance. Such a person is calculating and deliberate in their actions and potentially very damaging.

The 'shark-tooth' connection

This term denotes a mixture of angles and curved writing in the style of the script. It is one of the greatest signs of intense secretiveness and deceit and has a jagged appearance.

The shark-tooth is found in the writings of those who like to engage in sharp practice. It reflects a cutting and sarcastic edge, someone who takes pleasure in bullying and being cruel to people less intelligent than themselves. Their cruelty is carefully orchestrated to achieve maximum effect.

Shark-tooth movement needs only to appear vary rarely in a script to be of great importance. It is characteristic of those who give a good account of themselves and are able to convince you of their moral rectitude. Shark-tooth writers often assume a moral position while carefully making up the rules of whatever game they are involved in, and ensuring that they win, at someone else's expense.

A predominance of shark-tooth connections indicates an accomplished deceiver, who actually enjoys being manipulative in pursuit of their aims.

I give permission for this handwriting sample to be used in publication.

Forgery and fraud

Clearly one of the most fundamental manifestations of dishonesty in handwriting is the forgery of signatures. Identification of forged signatures is not so much graphology, or the analysis of handwriting, as it is quite easy to detect a forged signature. When an individual signs their own name it is done without thinking, whereas an imitator with a sense of purpose will invariably use heavier pressure on the paper, and the ending will often not correspond with the beginning, since concentration has diminished.

An unconscious minor stroke or a punctuation mark or i-dot that the real owner of the signature would not make will often give the forger away. Counterfeiters who attempt to trace a signature will be detected when a number of authentic signatures of the true owner are examined. In reality, each time we sign our name there is some slight variation. So if all versions of a signature are identical, they are surely tracings.

Equally important is the rhythm of the writing. A forger may be capable of copying features such as the angle of the writing and the formation of the letters but they will not be able to emulate the rhythm of the writing, which in turn reveals the personality of the writer. Although graphology is accepted in court for detecting forgeries, it's rarely considered ample ground for dismissal or prosecution. If you are seriously worried, call in the experts.

Case study

Judicial graphology, or document authentication, consists of examining a signature or handwriting to confirm whether or not it is a forgery, and attempting to identify the forger.

I was an expert witness in a case in the US where a minister of religion had engaged an engineer who had quoted $550 to remedy a problem. On completion of the work, the customer handed the estimate to the engineer, who returned to his car to retrieve his copy. When he returned, both copies of the estimate said $2,550!

The harassed customer paid the engineer, but then stopped the cheque. The engineer's company sued the customer and I appeared in court for the defence. I pointed out:

1. The shape of the '2' in the estimate was vastly different from the '550'.
2. Feeling the back of the page, the 'pressure' of the '2' was three times that of the '550'.
3. There was a suspiciously large gap between the $ sign and the figures – it looked like this trick had been tried before.

The judge examined the documents and halted the case with costs, saying it might go to a higher court. A few days later, the company cancelled the entire debt; they required no payment at all for the work completed. It was obvious that they had tried this before and did not want the case to go further and be reported in the press.

So, do not provide anyone with the opportunity to add or alter figures. Always think consciously when writing a cheque. Don't leave gaps between words or figures for others to insert additions.

Murder

Although graphology can reveal the character and motivation of a killer, there is no such thing as 'a murderer's handwriting'. No two writings are identical. But there are certain specific signs that can indicate a violent personality. For example, uncontrollable rages, hot temper and sadistic tendencies are all characteristics that can be seen in the script as warning signs.

Each murderer is an individual whose writing must be assessed to determine just what inner compulsion resulted in the taking of a life. The psychopath must be the most cold-blooded of all murderers, because they often have little motive for killing. Their external attitude may be pleasant on the surface, hiding an inner aggression so well that they are rarely suspected of antisocial behaviour. Their writing will have positive traits as well as negative, making them the hardest of criminals to detect.

Moving On

According to research published in 2013 by the National Pen Company in the USA, handwriting can give away clues to over 5,000 different personality traits. I hope that the information included here will help you carry out your own analysis so that you can amaze your friends, impress your family and also make good decisions about relationships. Handwriting can also uncover health issues, so make sure you are alert to any changes to your own script and that of your family.

With an open mind, self-analysis based on our own handwriting can also uncover personal issues or traits that we can work on, so don't be afraid to be objective when analysing your own script.

I hope that this book will also provide an additional tool in the workplace and help with the recruitment of staff, assist with business dealings and also identify possible fraudulent activity.

Most of all, I hope you have enjoyed reading *The Secrets of your Handwriting* and from now on you will view the handwritten word with a new and informed eye.

Index